For The Royal Table

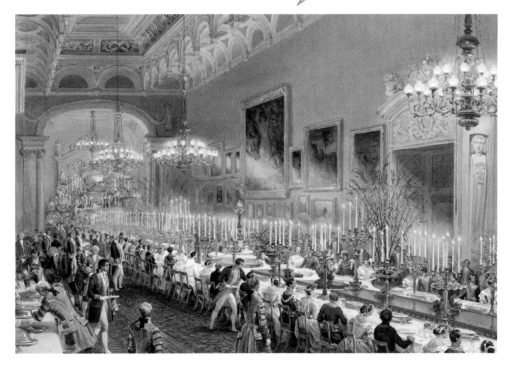

Published by Royal Collection Enterprises Ltd
St James's Palace, London SW1A 1JR

For a complete catalogue of current publications, please write to the address above, or visit our website on www.royalcollection.org.uk

ISBN 978 1 905686 11 7

British Library Cataloguing in Publication Data: A catalogue record for this book is available from the British Library.

Compiled by Kathryn Jones
Designed by Sally McIntosh
Production by Debbie Wayment
Typeset in Garamond
Printed on Symbol Tatami White, Fedrigoni, Verona
FSC Mixed Sources Certified Paper
CoC-FSC 000010 CQ
Printed and bound by Studio Fasoli, Verona

The historical documents quoted from and illustrated in this book have been selected for their interest and charm, and for the part they have played in the history of the royal banquet. They have been reproduced from originals held in the Royal Archives and other sources, and refer back to a time when knowledge of food hygiene – not to mention endangered species – was very different to today. They should not be regarded as practical recipes.

Readers who would like to try their hand at contemporary 'royal' recipes should follow those given on pages 58 and 82.

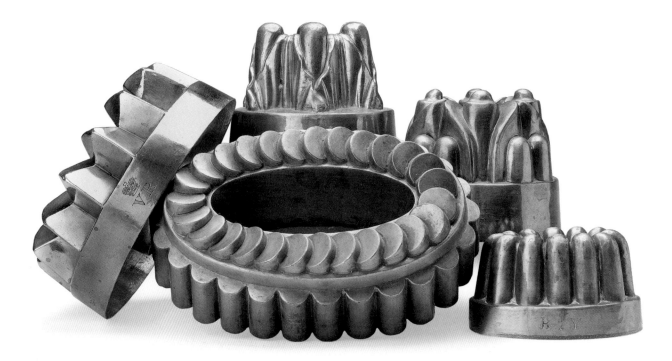

For The Royal Table

DINING AT THE PALACE

KATHRYN JONES

ROYAL COLLECTION PUBLICATIONS

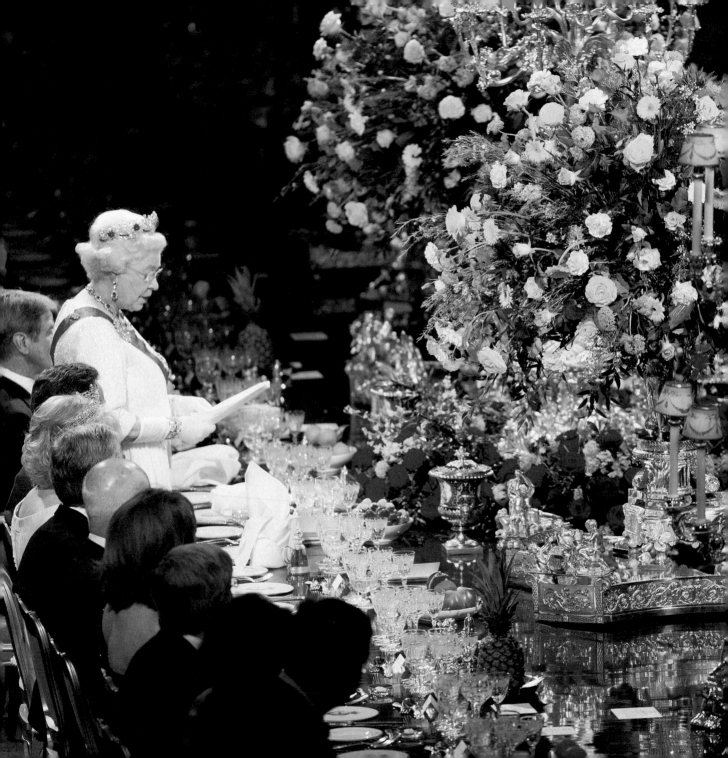

On 26 March 2008, Her Majesty The Queen and The Duke of Edinburgh entertained the President of France, Nicolas Sarkozy, and his wife at a State Banquet with 158 guests at Windsor Castle. The menu of four courses – fillet of brill, noisettes of lamb served with artichokes, broad beans, carrots, cauliflower and potatoes, followed by rhubarb tart with vanilla cream and dessert fruit – was served with a 2000 Chassagne-Montrachet and a 1961 Château-Margaux. The Queen spoke of celebrating the differences between the nations of France and Great Britain, whilst embracing their similarities. The President responded by talking of a great deal of mutual admiration and affection between the two countries. Toasts of Louis Roederer champagne were drunk. Musicians of the Irish Guards played during the meal.

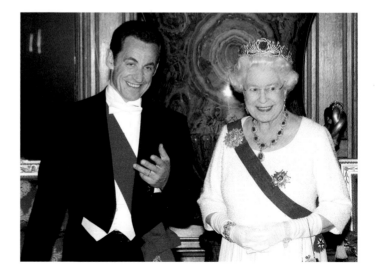

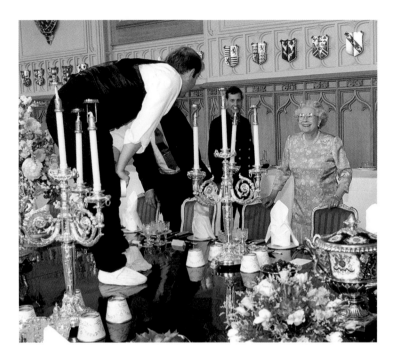

This was the 97th State Banquet of The Queen's reign. These events form an essential part of the monarch's role, taking place on the first night of an official State Visit – when a foreign Head of State is invited to Britain. The guests include members of the government, the diplomatic corps, and other important figures connected with the visiting nation. The banquet is both a welcome to the Head of State and a chance to cement diplomatic relations.

The Queen has entertained guests from all over the world. Most of these visits have taken place at Buckingham Palace, but eighteen have been hosted at Windsor Castle and two at the Palace of Holyroodhouse.

The Queen always keeps a close eye on the preparations for a banquet – approving the menu, the guest list and the seating plan and inspecting the table personally before the banquet to ensure that everything is in order.

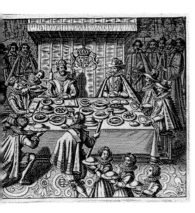

The idea of the royal banquet is as old as the monarchy itself. In 1315 a decree was issued which declared that 'feasts' were reserved purely for the monarch. Dining in public was an important ceremony and a way of offering access to the sovereign. Close members of the court were given the honour of serving the king – carving his meat and pouring his wine. Below, Charles I and his consort Henrietta Maria are watched over by a group of courtiers.

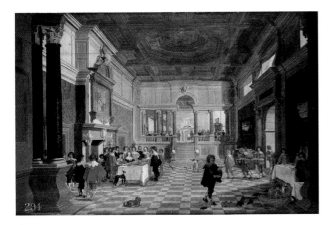

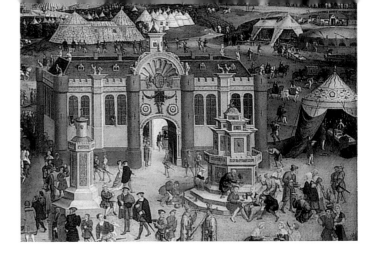

Hospitality and the forming of diplomatic relations have always been among the chief obligations of the monarch. One of the best-known diplomatic missions undertaken by an English king was that of Henry VIII to visit Francis I of France in 1520. They met near Calais, at the so-called Field of the Cloth of Gold. The monarchs vied to outdo each other in splendour. This depiction of the event shows the temporary palaces erected for the occasion – on the far right can be seen the catering arrangements, which were as important for diplomatic relations as any other part of the visit. In the foreground is a fountain flowing with wine, designed by the French to impress their English visitors.

Banquets have been held not just for foreign visitors but also for royal celebrations. Coronations and jubilees have been occasions for banquets, as have military victories. George IV celebrated victory over Napoleon with a glittering dinner at the Guildhall in London in 1814, to which the Emperor of Russia and the King of Prussia were both invited. The banquet (right) was planned and executed in only eight days.

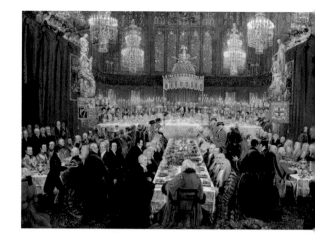

The gathering of the Knights of the Garter has traditionally been accompanied by a feast. The etching (left) illustrates one of Charles II's banquets for the Garter Knights, held in St George's Hall, Windsor Castle. At the dinner 145 dishes were served during the first course and the Knights were offered 16 barrels of oysters, 2,150 poultry, 1,500 crayfish, 6,000 stalks of asparagus and 22 gallons of strawberries.

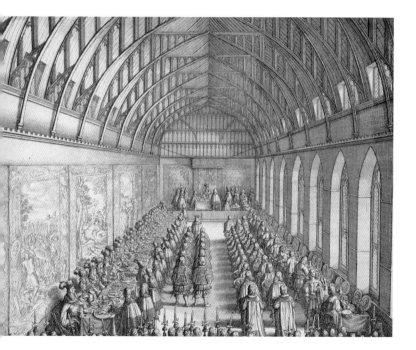

The tradition of the Garter feast continues today, although on a more modest scale, at an annual luncheon held at Windsor.

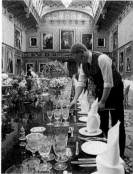

Family events such as christenings and weddings are also occasions for celebratory banquets – at the Wedding Breakfast of King George VI and Queen Elizabeth, for example, in Buckingham Palace in 1923, the menu included salmon, lamb, capon, asparagus and strawberries.

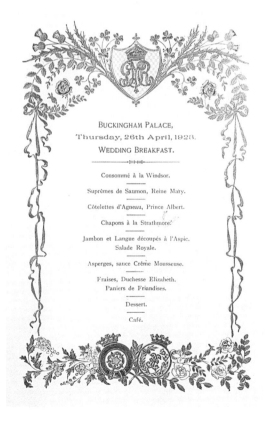

BUCKINGHAM PALACE,
Thursday, 26th April, 1923.
WEDDING BREAKFAST.

Consommé à la Windsor.

Suprêmes de Saumon, Reine Mary.

Côtelettes d'Agneau, Prince Albert.

Chapons à la Strathmore.

Jambon et Langue découpés à l'Aspic.
Salade Royale.

Asperges, sauce Crême Mousseuse.

Fraises, Duchesse Elizabeth.
Paniers de Friandises.

Dessert.

Café.

Victoria Soup

Wash and scald half a pound of Frankfort pearl barley, and put this into a stewpan with three pints of good white veal stock, and simmer it very gently over a slow fire for an hour and a half; by which time the barley will be nearly dissolved; remove a third of it into a small soup-pot; rub the remainder through a tammy or sieve, pour it to the whole barley; add half a pint of cream; season with a little salt; stir it over the fire until hot, and serve.

This soup may be prepared also with rice; they are… the only soups eaten by the Queen when I had the honour of waiting on Her Majesty.

Charles Francatelli (1805–76)
Master Cook to Queen Victoria

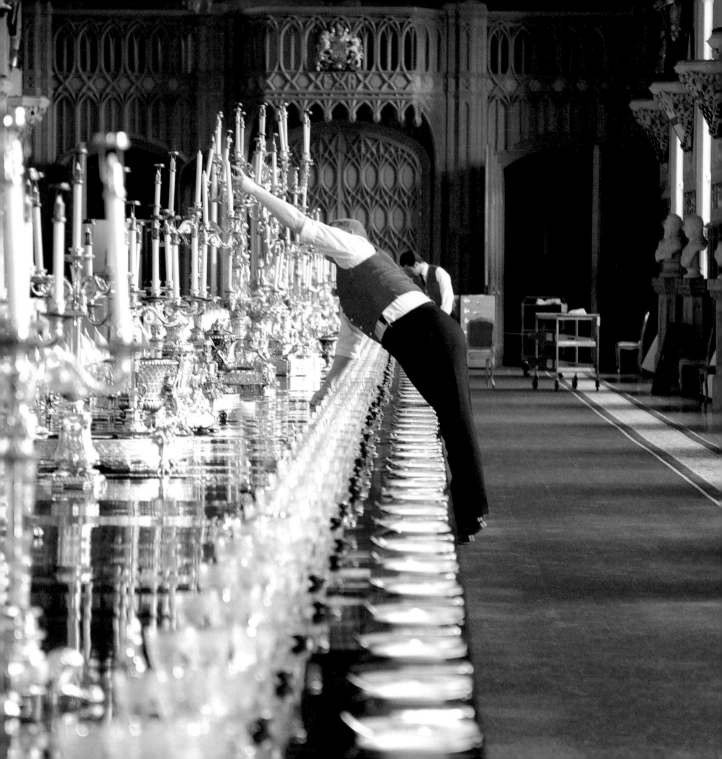

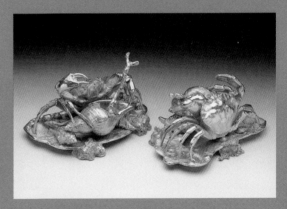

the Table

Banquets at Buckingham Palace are held in the Ballroom, around a large horseshoe-shaped table, with The Queen and the visiting Head of State sitting in the centre. The table length can be adjusted but the usual set-up measures 23 metres (75 ft) by 8.5 metres (28 ft), and is always clothed.

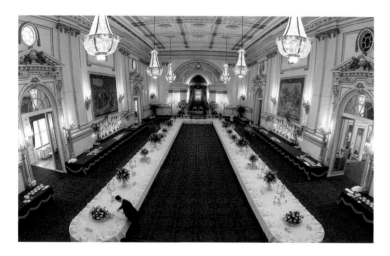

The Ballroom was built for Queen Victoria in the 1850s, with an adjacent Supper Room for dining. Originally the walls were colourfully painted with Renaissance-style decorations, but during the reign of King Edward VII the present scheme of white, gold and crimson was introduced. The Ballroom is ideally suited to a banquet as it is connected to the kitchens by a lift, so that hot dishes may be brought to the table quickly.

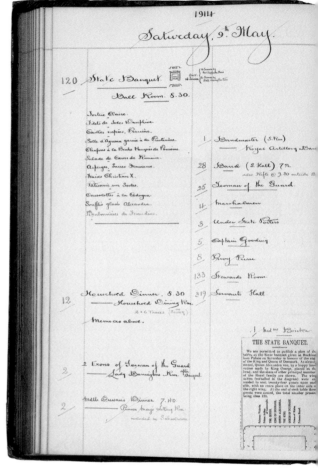

The ledger used to record every menu provided at the Palace includes a small diagram of how the table is to be set up. The arrangement echoes the feasts held by Henry VIII, whose table plan for a banquet following a tournament at Greenwich in 1517 is illustrated here.

The first banquet held in the Ballroom took place on 9 May 1914, when King George V and Queen Mary entertained the King and Queen of Denmark, Christian X and Queen Alexandrine, with 120 guests. They were served sole, quail, lamb and strawberries.

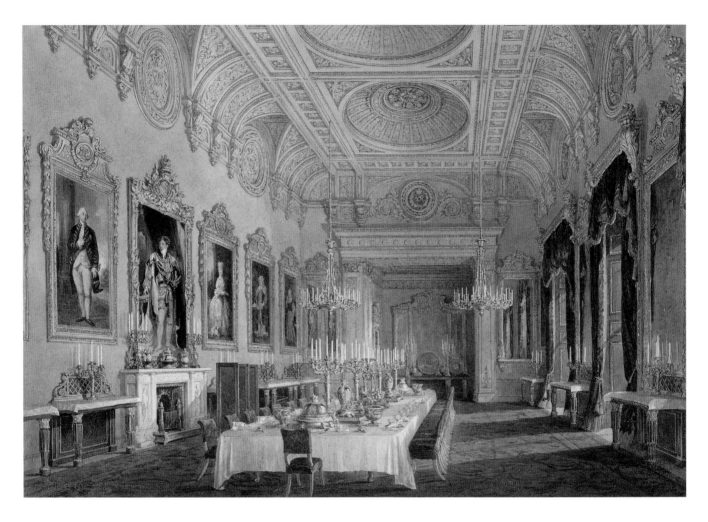

In the past banquets were held elsewhere in the Palace. The State Dining Room on the west front, overlooking the gardens, is shown here set for a dinner for Queen Victoria. Her guests frequently complained of the cold as she insisted on having the windows flung open while she ate. Queen Victoria was renowned for eating extremely fast, which meant meals were often uncomfortable for her guests, as protocol dictated that when the monarch had finished eating, all plates should be cleared.

Nevertheless the Aga Khan, who visited the Palace in 1897, was very impressed with the dinner he received: 'course after course, three or four choices of meat, a hot pudding and an iced pudding, a savoury and all kinds of hot house fruit. The Queen in spite of her age ate and drank heartily – every kind of wine that was offered and every course, including both hot and cold pudding.'

King George V and Queen Mary used the State Dining Room in 1923 for the Imperial Conference dinner (below), but it appears to have been inadequate in length and the table was extended into the West Gallery beyond.

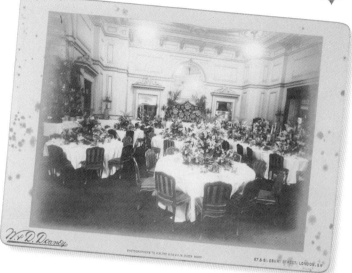

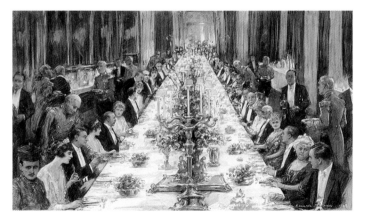

Most frequently it was the Ball Supper Room which was used for dining. It is seen above in 1913, laid out for the banquet held in honour of M. Poincaré, President of France. This room was usually set up with small round tables. The same arrangement was adopted at the Wedding Breakfast of Princess Elizabeth and the Duke of Edinburgh in November 1947.

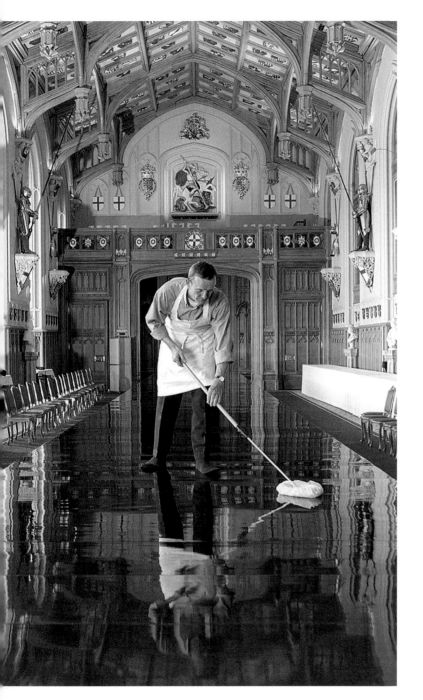

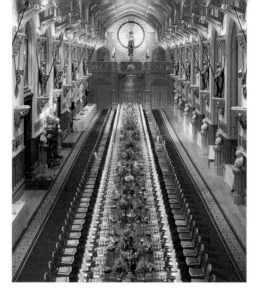

At Windsor Castle banquets take place in St George's Hall, at the magnificent polished dining table. The table was made in 1846. It measures 53 metres (175 ft) in length, is formed from 68 leaves of Cuban mahogany and can accommodate 160 guests. Before each banquet the table is polished to a mirror shine.

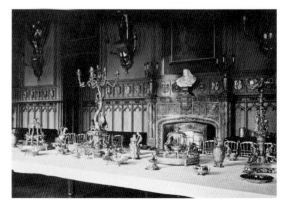

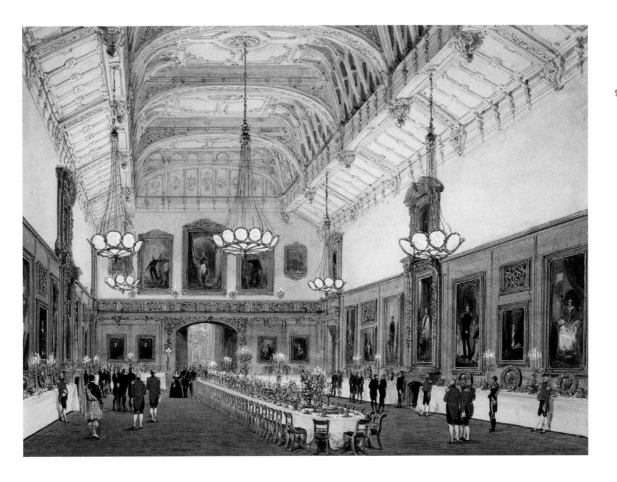

During Queen Victoria's reign all State Visits took place at Windsor Castle. In 1844, during the visit of King Louis Philippe and Queen Marie Amélie of France, the Queen noted in her Journal that 'We dined at 7… It really was very splendid. The King is full of admiration for these Banquets in St George's Hall.'

The Waterloo Chamber was also used and is shown above set up for a dinner held by Queen Victoria to welcome Tsar Nicholas I in June 1844. There is only room for a third of the dining table in the Waterloo Chamber. The room is now used for Garter luncheons.

The Royal Household staff start laying the table for a banquet two days before the event, although preparations will have been underway for days before this. One of the most striking elements on the banqueting table is the magnificent service of silver gilt. It comprises not only the dining plate itself, but also decorative items such as dessert stands and centrepieces, some of which are shown on the following pages.

Numbering over 4,000 pieces, the service was commissioned by George IV when Prince of Wales, and supplied by the royal goldsmiths Rundell, Bridge & Rundell. The initial order (left) included over £60,000 worth of plate.

The first delivery to the Prince's residence, Carlton House, took place in 1811, and throughout the rest of his life he continued to order items for the service, which became known as the Grand Service. George IV was the most theatrical of monarchs and everything was designed for display. At Carlton House (above right) niches were built into the Gothic Dining Room to display his silver. His chefs gave tours of the baize-lined plate room on the lower floor.

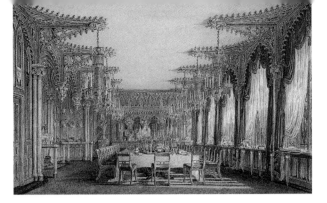

At a famous dinner held at Carlton House in 1811, the Prince sat against a backdrop of silver gilt at the head of a table that stretched the entire length of the building. Along the centre of the table was a running stream of water with banks of moss and aquatic flowers, cascading from a waterfall and falling into a series of pools at the foot of the table. Real fish swam in the stream. In this contemporary caricature, the fish are disconcerting the guests by staring at them.

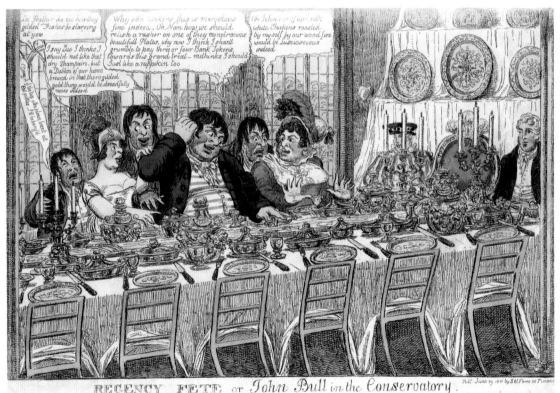

RECENCY FETE or John Bull in the Conservatory.

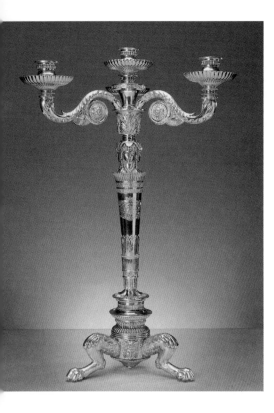

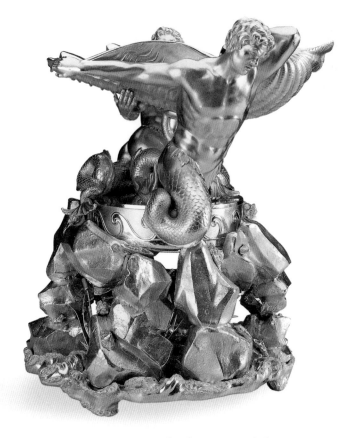

The Grand Service includes 14 tureens, 20 sauce tureens, 140 dishes, 288 dinner plates, 118 salts, 12 ice pails, 12 mirrored plateaux, 58 dessert stands and centrepieces and 107 candelabra. Unlike a modern dinner service, it has no single style of decoration. The goldsmiths of the day were influenced by Greek, Roman, Egyptian and oriental styles.

Parts of earlier services belonging to George IV's grandfather, Frederick, Prince of Wales, were adapted to form part of the Grand Service, and inspired various additional items such as the marine tureens with sea-horse bases (page 26).

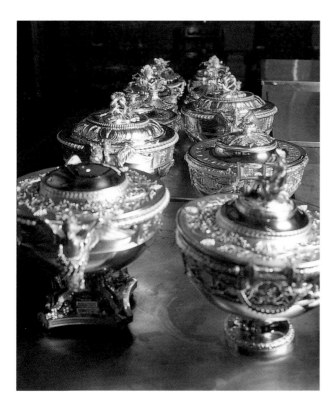

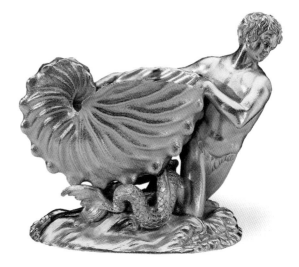

Originally some parts of the service were plain silver, although items intended for the dessert course were always gilt. However, George IV gradually ordered every piece to be gilded. This may have been because of the impression gained by one visitor to a ball at Carlton House in 1814: 'All was in gold or silver gilt which made the silver plate, set out in the deep recessed windows, look cold and poor, although in reality it was very massive and handsome.'

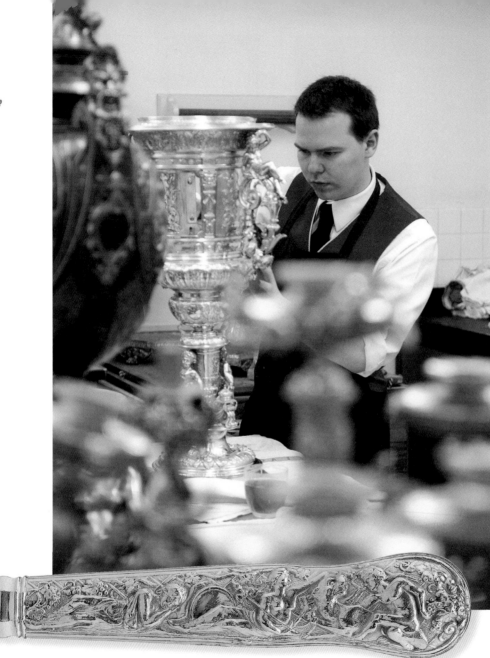

Today the Grand Service is kept under the care of the Yeoman of the Silver Pantry. When not in use, it is kept in a controlled atmosphere. For a State Banquet it must be at its most gleaming and every piece is taken apart, thoroughly washed and cleaned with soft brushes, then dried and polished with soft cloths before being placed on the table. When everything is dismantled, there are over 8,000 components to clean. It takes eight people three weeks to prepare.

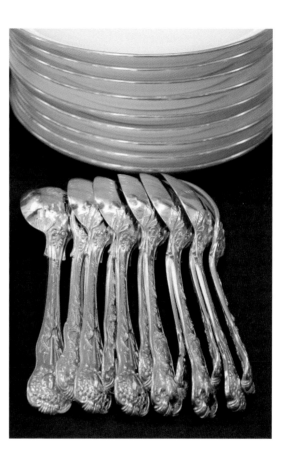

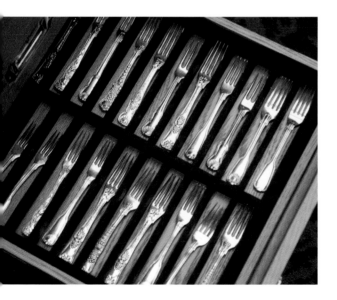

The Grand Service provides cutlery for every course and includes more obscure items like marrow scoops, ice spades and olive spoons. Today over 2,000 pieces of cutlery are needed to serve and eat the banquet – all drawn from the Grand Service.

The Queen's table is always decorated in the most magnificent style. She and her most important guest are usually flanked by the grandest pair of candelabra in the Service – which stand at 1.25 metres (4 ft) tall. These were designed by the sculptor John Flaxman and relate episodes from the myths of Bacchus and Mercury. The Queen uses a salt that is not part of the Grand Service but was made much earlier, in 1721, by Nicholas Clausen (left).

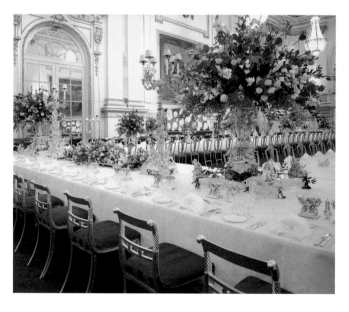

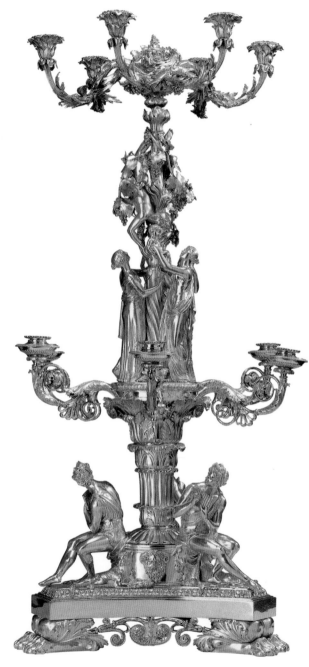

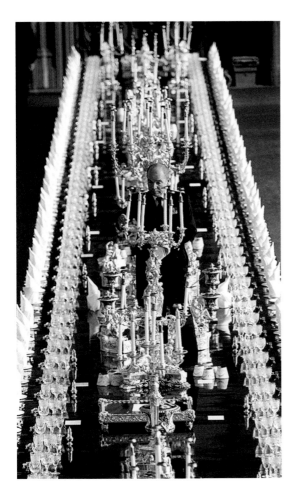

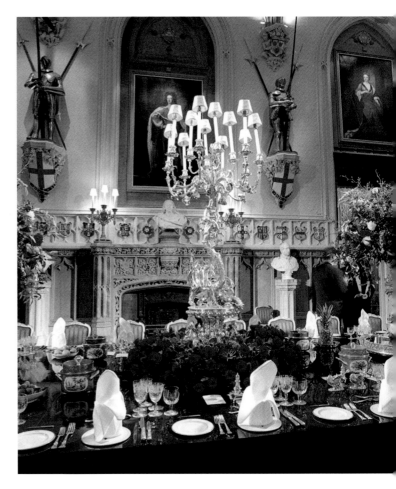

At Windsor, on the single long table, a candelabrum portraying St George and the Dragon is used – this stands even taller at almost 1.5 metres (5 ft).

This huge piece was William IV's contribution to his elder brother's dinner service – a final addition to the grandeur that has served every monarch since George IV.

Potage de Tortue à l'Anglaise (Turtle Soup)

Part 2

For a turtle of 150–200 lb, cut up 2 large legs of veal, also some lean ham in slices, which lay at the bottom of a large stewpan, buttered, then put in the veal, 8 fowls, 4 carrots, 4 large onions, and beef stock to moisten only the surface of the meat; set the pan over a quick fire, and let the reduction proceed slowly that the glaze may become of a fine light colour, then fill up the pan with beef stock and let it boil; strain and thicken it afterwards with a roux slightly coloured to obtain an Espagnol, or a sauce somewhat thick. While this sauce is boiling, place the flesh of the turtle not required for an entrée (except the fins and shells) at the bottom of a stewpan slightly buttered, and sweat them with a little stock upon a very slow fire, that they may simmer only for 3–4 hours, so as to obtain an essence; then get the largest pan possible, as the turbot kettle &c. and fill it 3 parts full of boiling water, throw in the 4 fins, then the 2 large shells (ensure the shells are covered, or turn them), remove scales; this finished, replace the turtle in boiling water for 3 or 4 hours, skimming it perfectly, observing from time to time if the flesh of the fins is done enough to take up; when the flesh of the shell separates from the bones, take them up and lay them to cool on a baking sheet.

Part 3

Whilst meat is boiling, set over the fire a seasoning thus prepared: put in a stewpan ½ of the nut of a ham, cut in large dice, with 4 carrots, 4 onions, 4 pottles of mushrooms cut into slices, 1 lb of butter, 20 anchovies washed, a small handful of whole parsley, about ½ of that quantity of thyme, basil, marjoram, rosemary, savory, 10 bay leaves, a good pinch of cloves, as much cayenne pepper, allspice, mace, long pepper, white pepper and 2 ladlesful of consommé; simmer the whole over a slow fire for 3 hours, after which rub the whole through a tammy, and set it away in a *bain Marie* stewpan.

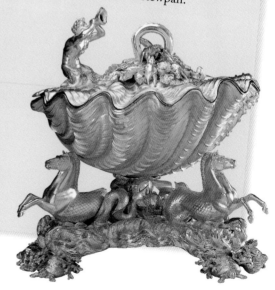

Part 1

Prepare and joint the turtle.

Part 4

Strain the essence of turtle through a tammy, reduce it separately to a strong glaze; at length, when the flesh, the fins, the head, and shells are cold, remove all the flesh and cut it in small squares 1 inch wide, trimming them neatly and removing all the fleshy particles from them; thus prepared, boil the turtle in 8 bottles of dry Madeira wine for ½ an hour, and afterwards turn it into one large pan containing the Espagnol perfectly clarified and passed through a tammy; add ¾ of the seasoning passed as a purée, let it boil for 10 minutes; taste it to be certain of its flavour: if necessary, add the remainder of the purée, acting very cautiously, as no particular thing should predominate on the palate. Add 50 small eggs thus prepared – pound 6 yolks of eggs boiled hard, mix salt and fine pepper, a little grated nutmeg, 3 raw yolks, and a little béchamel; form this into balls of the size of a nutmeg, poach them in boiling consommé and put them in the soup; after boiling a minute divide the soup into basins, large enough to hold sufficient for 12–15 persons; observe to put in each of the basins equal portions of the meat, eggs and fat of the turtle; quenelles of fowl and mushrooms (very white) may be added.

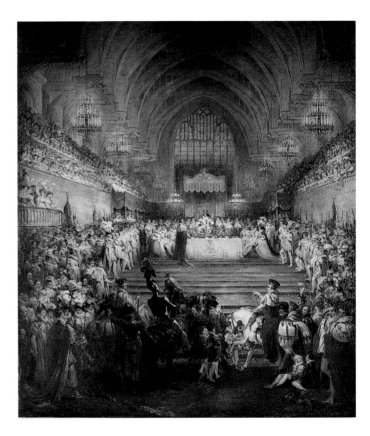

Turtle soup was George IV's favourite dish and 80 tureens of this delicacy were served at his Coronation Banquet in July 1821. It was usually served with punch.

'It is an awkward affair to make this soup on the same day as a large dinner.'

Antonin Carême (1784–1833)
Master Cook to George IV

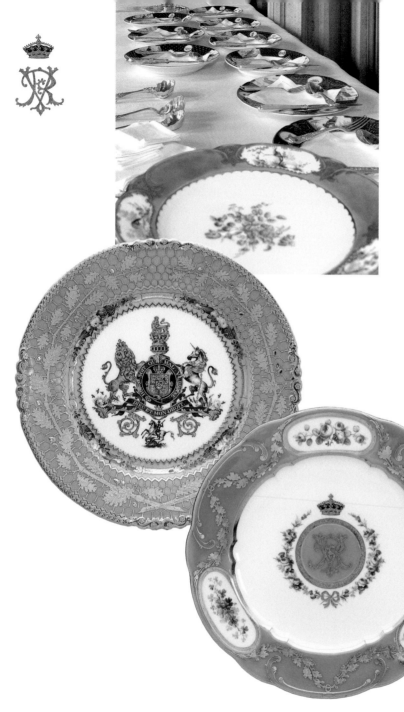

The third and fourth courses of the banquet are served on porcelain. The Queen has 47 dessert services to choose from, although not all of them are large enough to serve 170 guests. The plates illustrated here come from five different services and have all been used during the present reign.

The pale blue service decorated with gold oak leaves and the royal coat of arms was created for William IV, who was a great patron of English porcelain. It was made at the Rockingham factory in Yorkshire. The turquoise-rimmed plate is from a service made by the Minton factory in Staffordshire, which was a favourite of Queen Victoria. Her monogram is seen in the centre of each plate. This colourful service is often used to decorate the table, with pyramids of fruit stacked in the comports and stands.

The Queen also uses two French services from the Sèvres factory. These were made in the 18th century and acquired by George IV, who collected French porcelain as enthusiastically as he did silver. The other service (below centre) is from Tournai in present-day Belgium. It is decorated with delicately painted birds and is beautifully gilded, on a dark blue background. It is usually reserved for the fruit course of a banquet, and it too was acquired by George IV.

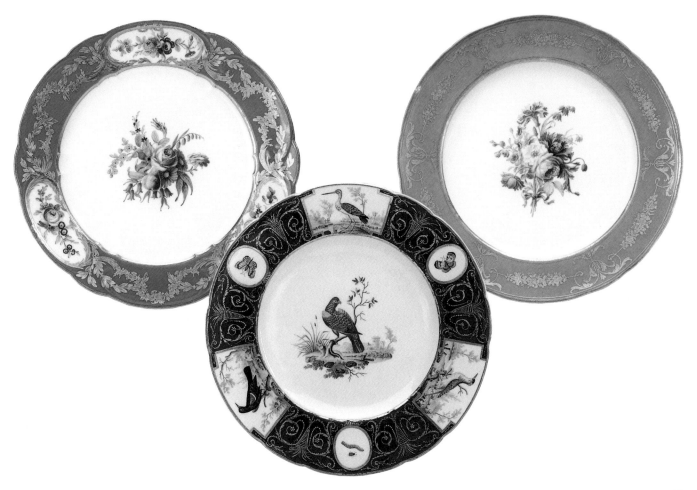

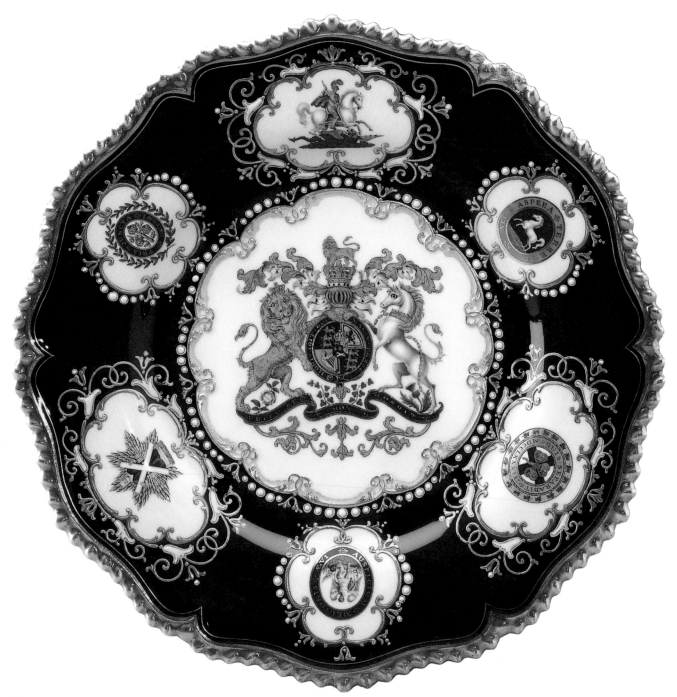

At Windsor Castle The Queen often uses a service made by the Worcester factory for William IV and decorated with the badges of the Order of the Garter and others of the King's orders. This is used at the annual luncheon which is held in June after the Garter service in St George's Chapel.

Other pieces of porcelain, such as the tureens from a Meissen dessert service, have been used to decorate the banqueting table. This example (right) was used in October 1958 for the dinner held for President Heuss of Germany.

The rest of the porcelain used today – the side plates and crescent-shaped salad plates – is more modern and carries The Queen's cipher (see p.109).

'First-class fruits possess in themselves an all-powerful attraction to the admiring gaze of all who behold them, yet it cannot be denied that their beauty is still further enhanced when tastefully grouped in graceful pyramids upon rich services in old Sevres, Dresden or Chelsea china.'

Charles Francatelli
Master Cook to Queen Victoria

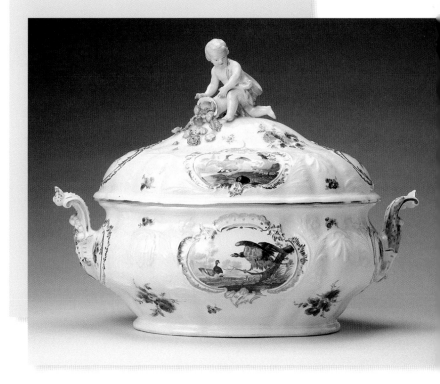

Until the mid-18th century it was more usual to serve dessert on silver-gilt plates, but porcelain became increasingly popular. George III and Queen Charlotte purchased several services for dessert. The service illustrated here was commissioned from the Sèvres factory by the Spanish Ambassador, the Marquis del Campo. The Marquis held a splendid gala in the Rotunda in the Ranelagh Gardens, Chelsea, to celebrate the recovery of George III from his first bout of porphyria. The Queen and her daughters all attended. The cost ran to £12,000.

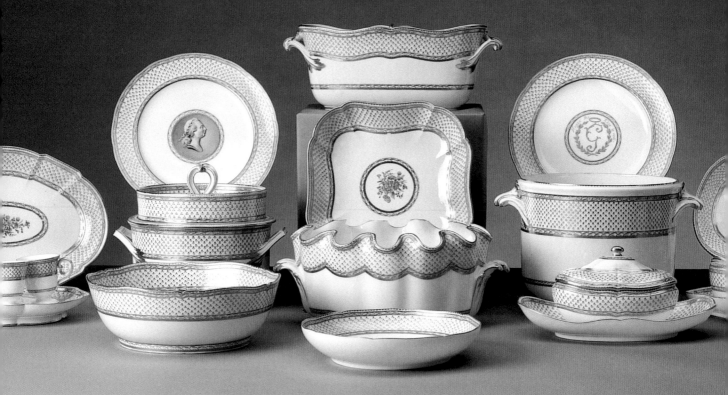

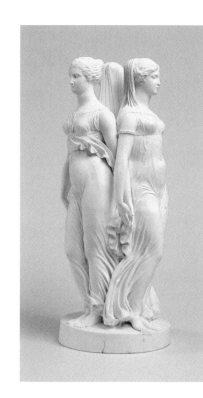

Porcelain figures were also used to decorate the banqueting table, often during the dessert course, when the table would be decked to resemble a formal garden with parterres. Many of these figures were of biscuit porcelain (unglazed white porcelain) – examples from the Sèvres factory survive in the Royal Collection. George III was sent a diplomatic gift of a dessert service by the King of Naples, which included an enormous biscuit porcelain centrepiece of King Tarchon of the Etruscans watching over gladiatorial combats. The only remaining illustration of this enormous creation is the engraving below.

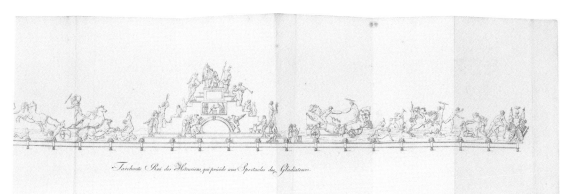

Tarchonte Roi des Hétruriens, qui préside aux Spectacles des Gladiateurs.

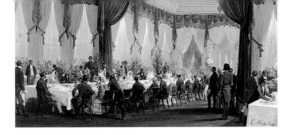

In the 1850s Queen Victoria entertained several Heads of State. In each case the guest was also invited to the Guildhall by the City of London. The City went so far as to order special plates honouring the guest, and samples of each plate were sent to the Queen for approval. These include designs for the King of Sardinia, Victor Emmanuel II, and the Emperor Napoleon III of France. They were made by a porcelain factory in Coalbrookdale, in Shropshire. The designs reflect the Anglo-French *rapprochement* in the face of a common enemy in the Crimea.

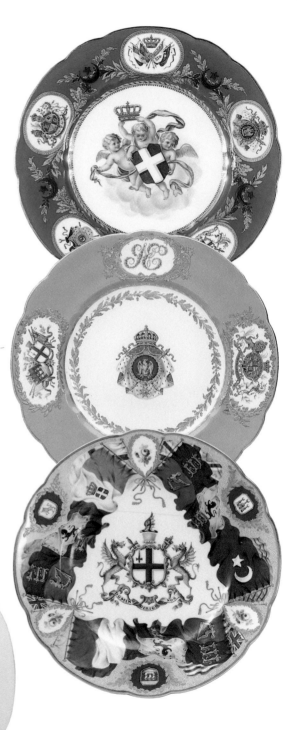

Over a thousand glasses are used at a banquet. Every guest is given six glasses – one each for champagne, white wine, red wine, port and water. A further champagne glass for the toasts is also provided. Each guest also receives a glass finger bowl during the fruit course, usually placed on top of a linen doily and a Tournai porcelain plate. The glasses used at Buckingham Palace were ordered from Stourbridge for The Queen's Coronation in 1953, and all bear the EIIR monogram.

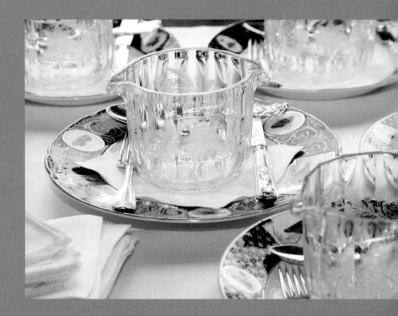

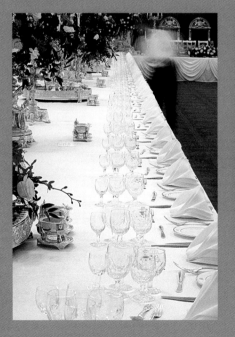

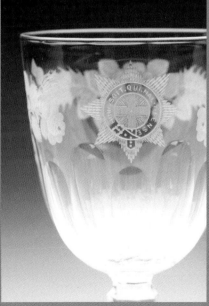

A different set of glasses is used for banquets held at Windsor Castle. These are engraved with the Garter Star – the badge of the Order of the Garter. The original design was created for George III at the Waterford factory in Ireland.

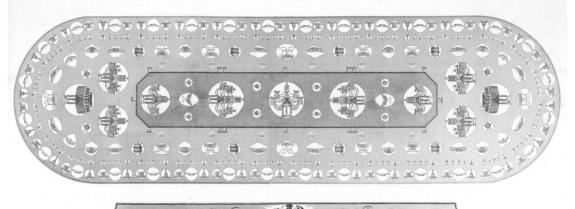

To his Royal Highness The Duke of York. This Plate which represents the Plan of a Dessert Service of Glass, executed in 1802 for HIS IMPERIAL MAJESTY, ALEXANDER, EMPEROR OF ALL THE RUSSIAS, Is most humbly and respectfully dedicated by His Royal Highness's very devoted and obliged Servants, Hancock, Shepherd & Rixon, London.

In 1802 Frederick, Duke of York (second son of George III) ordered a complete glass service for a dessert course from the chandelier manufacturers Hancock, Shepherd & Rixon. This was intended for a banquet to entertain Tsar Alexander I of Russia. It was not only a service of drinking glasses; it included elaborate candelabra, known as lustres, and dessert stands for displaying fruit. Glass was considered an elegant alternative to porcelain for showing off the dessert course.

The glass below was ordered by George IV in 1808 after a banquet held in Liverpool in his honour, where similar glasses had been used. The City of Liverpool ordered a full set as a gift without realising the cost – the service comprised over 500 pieces including decanters, coolers, carafes, water jugs, and six dozen each of claret and port glasses, each with a Garter Star cut into the foot. The final bill came to more than £1,000.

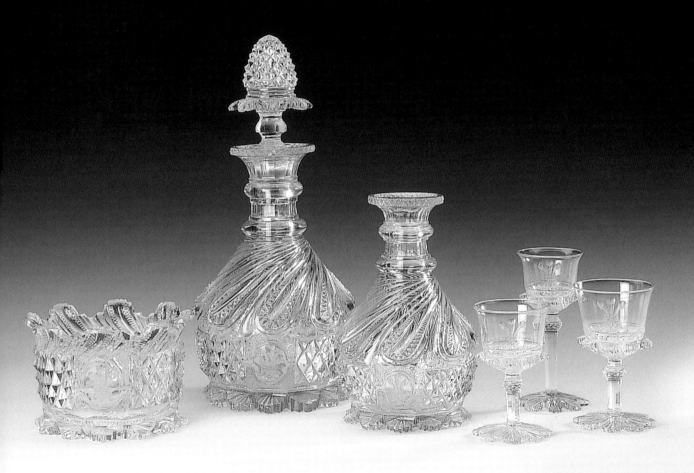

At Buckingham Palace, the banqueting table is covered by 7 linen tablecloths of finely woven damask. The cloths measure 68 metres in length altogether (74 yards). Sometimes it is necessary to hem the edges of the cloths once they are in place to ensure they hang evenly all around the table. The front of The Queen's table is dressed with damask festoons – another tradition that goes back to George IV, who had a similar arrangement at his coronation banquet.

The linen room of the Palace also provides napkins and doilies for each person. The napkins are crucial in working out the measurements of the place-settings as they are the first items placed on the table when laying begins.

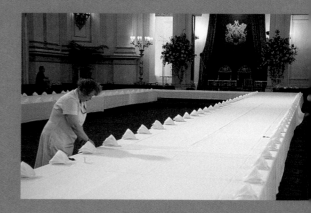

At Buckingham Palace the napkins are folded into a Dutch bonnet shape. The Yeoman of the China and Glass Pantries folds each napkin himself.

At Windsor there is no need for a tablecloth. The table is so highly polished it acts like mirror glass reflecting the gleam of gilt plate, glass and candlelight. The napkins there are folded into a taller, Prince of Wales feathers' form.

The doilies, each embroidered with the EIIR monogram, are used during the fruit course – they are placed on the plate under the finger bowl.

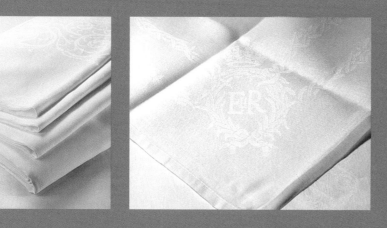

Most of the linen used in the Royal Household has traditionally come from Ireland. Several historic cloths are still kept in the linen room, including one made in 1821 for George IV, to celebrate military victories in the Napoleonic Wars.

It is kept in a brown-paper wrapper, carefully marked with each decorative element so that it is possible to work out which way it should be laid on the table.

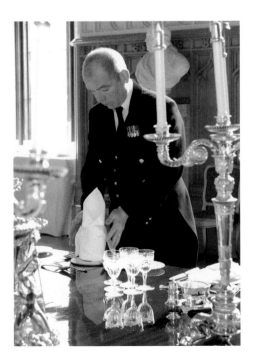

The name of the maker, J.W. Coulson of Lisburn, is woven into one edge of the cloth.

How to fold a Dutch bonnet

Start with a large square starched napkin.

Fold in half (horizontally) and in half again (horizontally) so that you have a long thin strip. Fold in half (vertically) and fold each end back towards the middle. The napkin will now be in a small square.

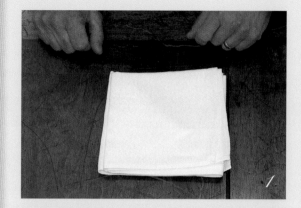

Open out two halves and lie flat so that the 'loose' ends of the napkin are on the underside.

Fold upper left and upper right corners diagonally towards centre fold to form a large triangle with point facing away from you.

Bring lower corners together in a 'loop', one end slightly overlapping the other, and hold firmly.

Turn over so that the loose folds are facing you.

Starting from the outer layer, peel out each corner in turn (3 on each side).

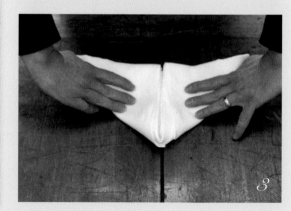

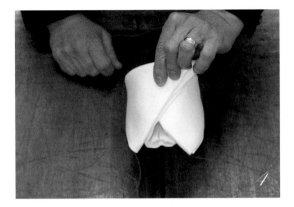

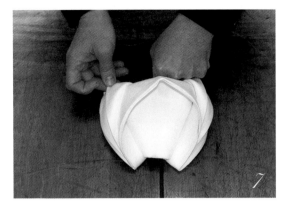

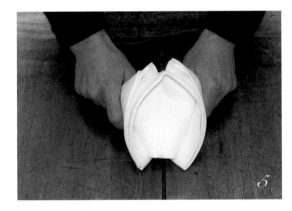

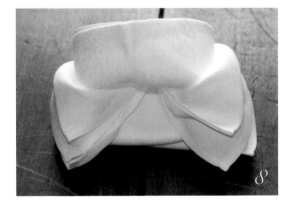

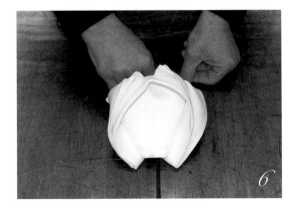

The idea of folding napkins derives from Italy, where animal shapes were popular in the 15th century. After the Restoration, it became fashionable in England to 'pinch' or fold napkins. Samuel Pepys paid 40 shillings for his wife to be taught the art, having seen it at court.

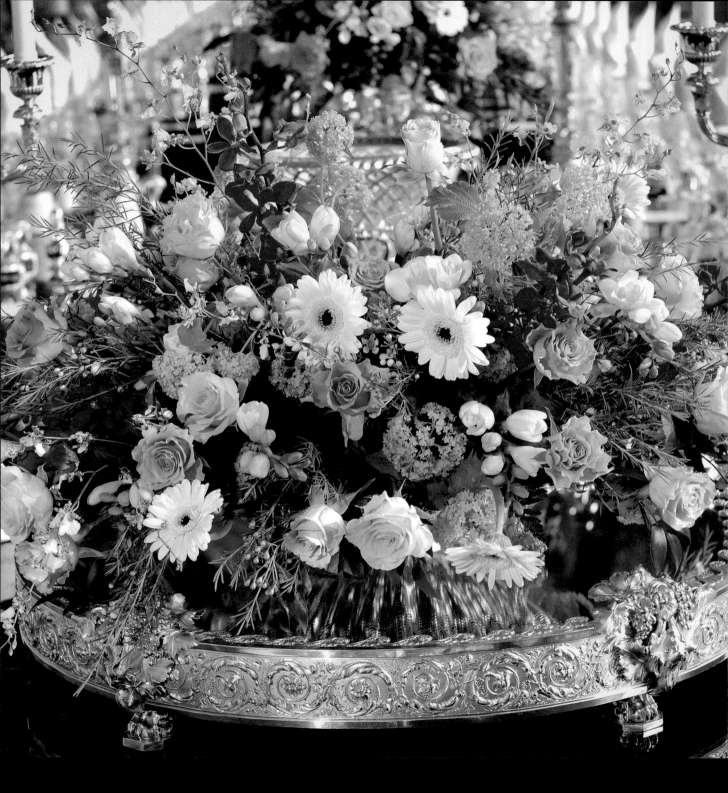

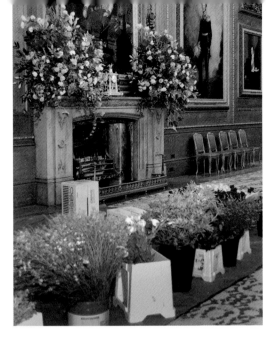

Seasonal arrangements are used but flowers are also chosen for their scent and colour. In the Ballroom at Buckingham Palace, strong reds are most successful, because they tone with the colours of the room – the carpet, the throne canopy and the fabric used to dress the serving tables around the sides of the room. At Windsor colours are more varied. For the State Visit of the President of France, spring flowers in shades of cream, pink, peach and red were used.

The royal florist, who arranges all the flowers for The Queen, has a team of six to help her create the 23 arrangements placed on the banqueting table, as well as the nine larger arrangements placed around the room. Some of these arrangements are relatively small, but others tower up to 2 metres (6½ ft) tall. A delivery of flowers is usually made two days before a banquet and the flower-arrangers spend 36 hours making the arrangements. The Queen takes a close interest in the flowers used, and always speaks to the flower-arrangers when she comes to inspect the table.

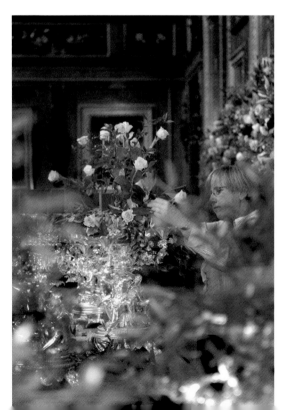

This concern for colour is not new. Edward Goodyear, who arranged the flowers during the reign of King George VI, suggested red gladioli and dahlias to tone with the colours in the Ballroom. In a letter to the Master of the Household, he suggested 'shades of pink and crimson, as it always looks very lovely with the crimson carpets, hangings and the slightly tinted colour in the lighting of the chandeliers…' In 1939, for the visit of the French President Albert Lebrun, the table was decorated with red roses, amaryllis, azaleas and orchids. This dinner must have been particularly crowded as there were 195 guests present.

Fashions for flowers have changed continually. Until the mid-18th century it was more usual to use artificial flowers on the table, as the scent of fresh flowers was considered distasteful when mingled with the smell of food. Elizabeth I used 'lardge sylke fflowers' and 'branches of flowers made of ffethers'. By the early 19th century fresh flowers were being used more frequently.

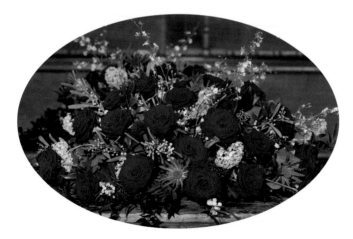

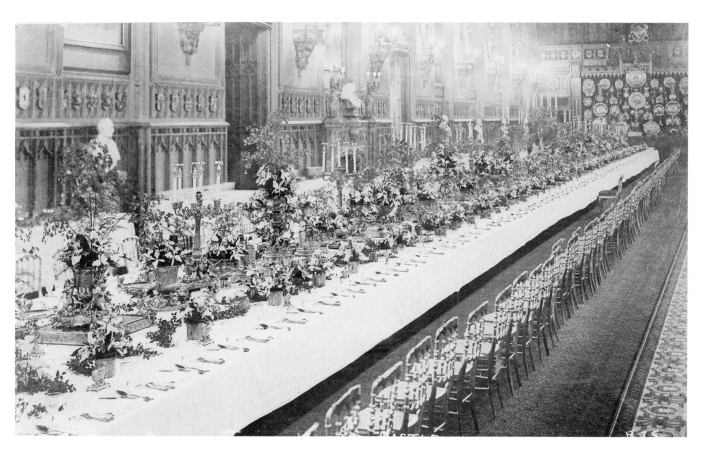

At a ball held on 5 February 1813 at Carlton House, the Prince Regent's steward noted that an arrangement of flowers should be placed in front of the Prince during the meal. At his coronation banquet in 1821 the order for flowers included 24 rose garlands, 12 white garlands, 72 branches of laurel and willow, and 72 bulrushes.

Historic photographs show the use of oak branches on the table at Windsor in 1915. This was presumably intended to be a patriotic gesture, during the first World War.

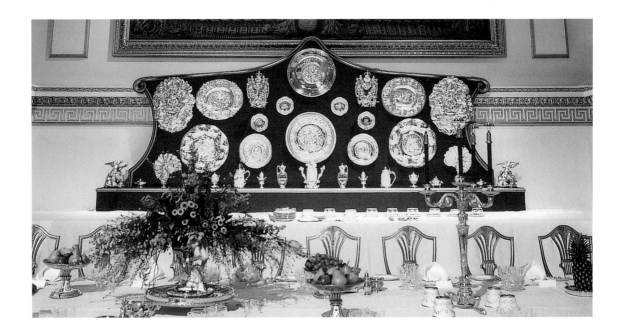

At Buckingham Palace the Ballroom is decorated with two large buffets of silver gilt from the Grand Service. On display are pieces such as 17th-century candle sconces; huge dishes decorated with biblical or mythological scenes; monumental flasks, jewelled cups, ivory tankards, silver-gilt bowls and dishes. These lamps in the form of phoenixes were originally intended to warm plates or dishes supported on their outspread wings.

Traditionally the buffet was a means of impressing guests with the wealth and power of the monarch. In England the buffet has always been a purely decorative feature: although many of the items on the buffet were practical they were not intended to be used during the meal. The Venetian Ambassador to the court of Henry VIII in July 1517 wrote of a 'buffet 30 feet in length, 20 feet high, with silver vases and vases of gold, worth vast treasure, none of which was touched'.

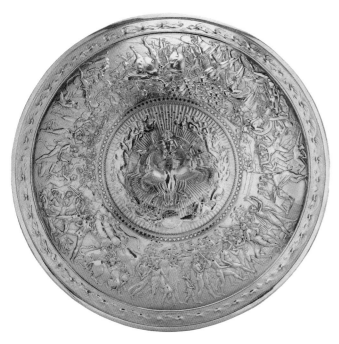

George IV created extraordinarily lavish buffets. The Shield of Achilles – an enormous piece of silver gilt 90 cm (35 in) in diameter and cast with Apollo in his chariot riding forth from the centre – was created for his coronation banquet and was prominently displayed on the buffet. The tradition was continued by later monarchs. The watercolour and photograph below both show buffets created for Queen Victoria at Windsor Castle.

After one of his banquets at Greenwich, Henry VIII ordered that the buffet remain in place for three days so that it could be seen by curious members of the public.

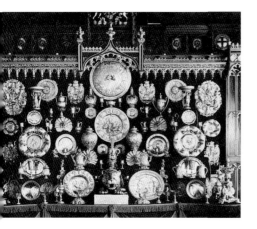

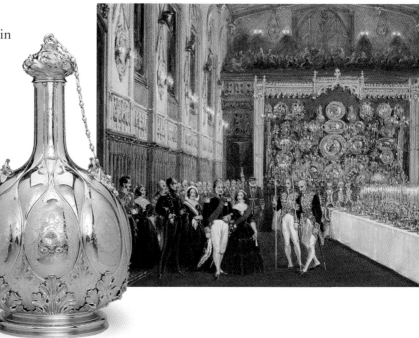

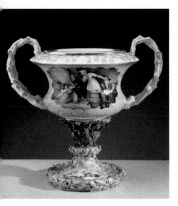

As recently as 1913, in the Ball Supper Room at Buckingham Palace, the French President M. Poincaré was entertained while surrounded by an enormous buffet of plate, as recorded in the photograph at right.

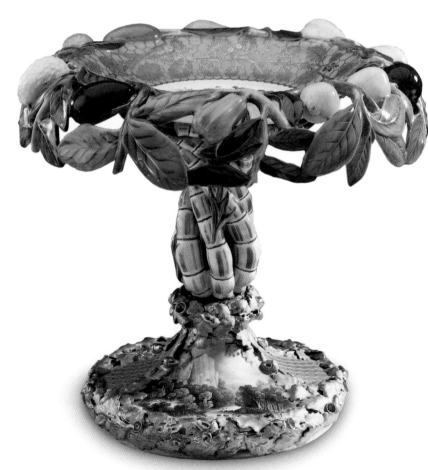

Another buffet is set up in the Ballroom, beneath the organ balcony. This is used to display the Rockingham dessert service made for William IV between 1830 and 1837. The service includes fruit stands of exotic shapes, incorporating pineapples, sheaves of wheat, guavas, branches of coral and bamboo, and celebrated England's overseas territories and the King's own naval background. The plate shown on p.28 is part of the same service.

Côtelettes de bécassines à la Souvaroff

Served at the Coronation of King Edward VII, 1902

Take 8 snipe, boned except for the leg bones, and put the 2 cutlets each makes on a dish. Season with pepper and salt, pour a drop of brandy on the top of each, spread with a little farce of game about half an inch thick, then more forcemeat. Gently place each cutlet in a pig's caul, wrap and brush over with the yolk of egg and breadcrumbs. Grill both sides until brown.

Serve on a silver dish bordered with potatoes and forcemeat, heaping in the centre beans, truffles and mushrooms. Serve with Madeira sauce made with small slices of truffle.

Gabriel Tschumi (b.1882) Master Cook to Queen Victoria, King Edward VII and King George V

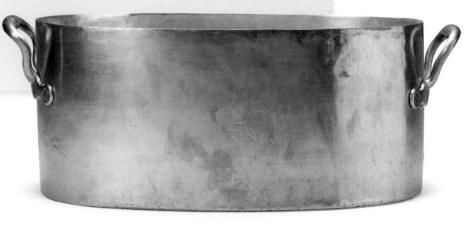

The table is laid for a State Banquet by eight to ten people. It requires very precise measurements and the exact alignment of each piece. It is undertaken by the teams in the Silver and China Pantries, overseen by the Palace Steward. During Queen Victoria's reign there were five permanent members of staff to lay the tables, known as Table Deckers.

Once the tablecloths have been laid, the napkins are usually the first items to go on the table. Each guest is allowed 18 inches (46 cm) for their place setting. A setting comprises two knives and forks with a dessert spoon and fork above; to the left of each place are a porcelain side plate and a silver butter knife, and a small glass butter dish.

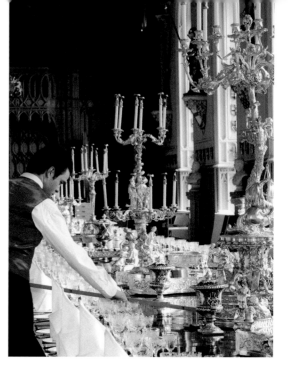

The plates are not laid on the table as they are heated in advance of the banquet, ready for the first course.

Each guest shares a salt, mustard pot and pepper caster with their neighbour. A place card with the name of the guest is also placed at each setting, with a menu card between each pair of guests.

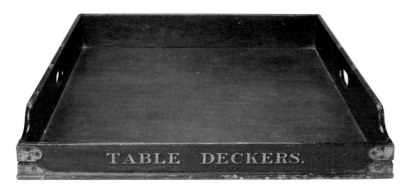

TABLE DECKERS.

The large central pieces such as the flower stands and candelabra are placed on mirrored plateaux which reflect the gleam of the gilt plate and the candlelight from above. William Kitchner recommended in *The Cook's Oracle* of 1821 that there should be half as many candles as there are guests.

In such a large space as the Ballroom, or in St George's Hall in Windsor, the average is slightly higher and 104 ivory-coloured 12-inch candles are used during a banquet. The Yeoman of the Pantries usually wraps strips of tape around the base of each candle so that it fits firmly in the nozzle of the candelabra. Small paper shades on metal frames are placed on top of the candles so that the light is diffused.

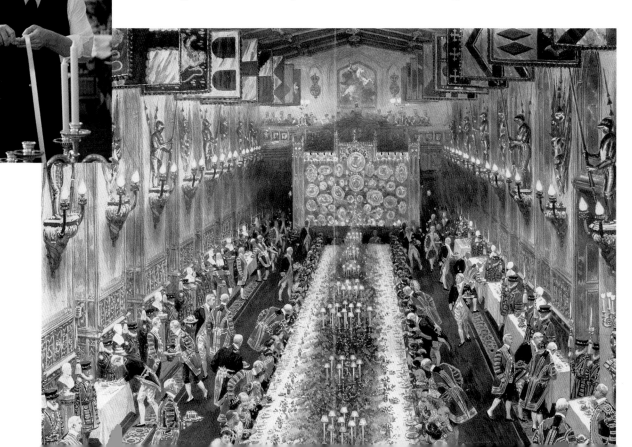

The artist Bryan de Grineau recorded a banquet at the Palace in 1950 (right). Sir Roy Strong attended a banquet in 1976, and later wrote in his diary:

'The scene here was out of an aquatint of the court of George IV. The tables were an explosion of damask, silver gilt, glass and flowers: huge silver-gilt candelabra piled high with sweet peas and roses were interspersed with smaller gold vases of flowers, all the cutlery being silver gilt. Vast chandeliers lit the room but what was quite extraordinary were the three great buffets with displays of plate done in a manner Louis XIV would have recognised. Behind each ascended boards upholstered in deep crimson velvet which were studded with huge pieces of gold plate and baroque wall sconces. Yeomen of the Guard in crimson and black, wearing chin-ruffs and holding halberds, lined the perimeter of the room. By the serving tables stood batteries of footmen… The impact on entering can only be described as dazzling.'

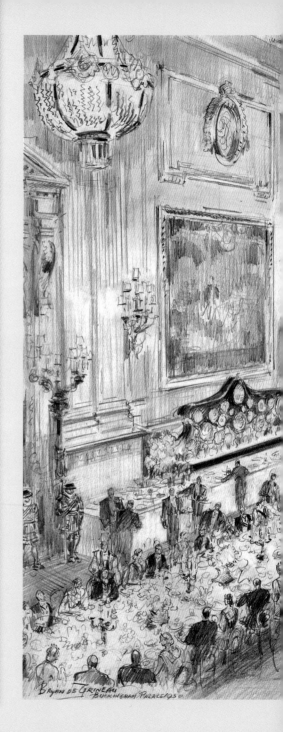

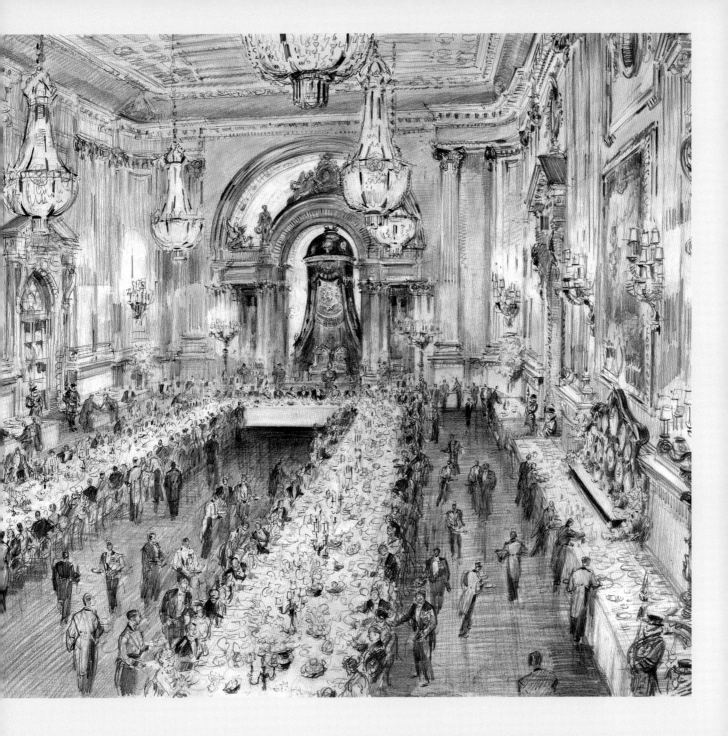

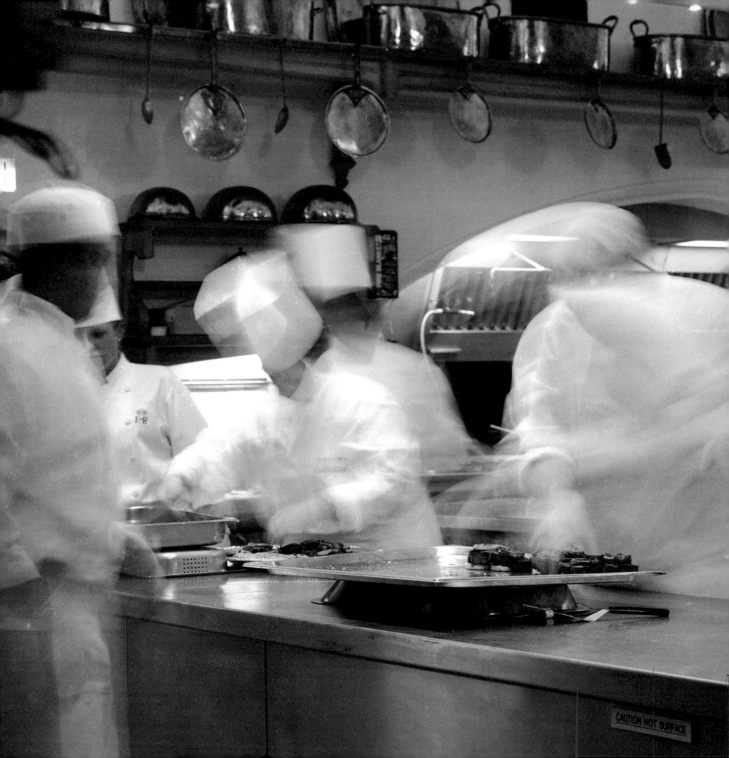

the Food

LE MENU

Roulade de Sole Royale

Canon d'Agneau au Basilic
Légumes Panachés
Brocolis Pourpre
Pommes Normande
Salade

Torte au Chocolat Blanc et Barbadine

Fruits de Dessert

LES VINS
Chassagne-Montrachet,
Marquis de Laguiche 2000, Joseph Drouhin
Château Montrose, 2ème Cru Classé,
St. Estèphe 1986
Louis Roederer, Brut 1996
Warre 1977

MARDI LE 13 MARS 2007

BUCKINGHAM PALACE

LE MENU

...elouté Tourangelle aux Truffes

...Médaillon de Saumon Poché
Sauce Mousseline

...oussin Poêlé au Champagne
Courgettes Sautées
Pois Gourmand
Pommes Fondantes
Salade

...herry Ratafia Parfait

...trachet, Les Vergers 1996,
...ine Gagnard
...e-Poyferré, 2ème Cru Classé,
...1985
Louis Roederer, Brut 1990
Dow 1977

MARDI LE 24 JUIN 2003

BUCKINGHAM PALACE

LE MENU

Consommé Hélène

...oup de Mer Poché Printanière

...e d'Agneau Farcie aux Herbes
...arottes Chantenay et Fèves
...Petites Courges Panachées
Pommes Nouvelles
Salade

...rine de Chocolat et Vanille

...rachet, 1er Cru Le Clavaillon,
...laive 1998
...oja 1999
...de Année 1996

...2005

BUCKINGHAM PALACE

The menu for a State Banquet is decided several months in advance of the visit. The Head Chef offers two alternative menus for approval to The Queen, who always makes the final selection. The menu is written in French, the traditional language of cookery, and usually consists of four courses – fish, meat, pudding and dessert (fruit). This is a considerable reduction since the days of Queen Victoria or King Edward VII, when twelve or fourteen courses were more normal.

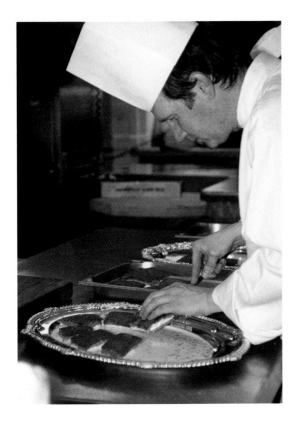

of the royal menu cards.' On the menu shown below, the dessert was named *Soufflé Glacé à la Reine Maud* after the Queen of Norway, who visited Buckingham Palace in 1907. An illustration of a Norwegian fjord was also included.

During the reign of King Edward VII the idea of honouring the visiting Head of State by a reference in the menu was first introduced. Gabriel Tschumi, who worked as a cook in the royal kitchens under three different monarchs, explained in his autobiography that 'some attempt was usually made to please foreign guests attending dinners or banquets by a reference to their country in the preparation

NAERÖFJORD, NORWAY. Hans A. Dahl

Caviar de Sterlet.
———
Consommé à la Grimaldi.
———
Crème d'Eperlans à la d'Orléans.
———
Zéphires de Cailles à la Montagné.
———
Epigrammes d'Agneau de Pauillac, Parisienne.
———
Pintadons et Poussins sur Canapés.
Salade à la Victoria.
———
Asperges, Sauce Mousseline.
———
Timbales à l'Espagnole.
Pâtisseries sur Gradins.
———
Cassolettes à la Napolitaine.
———
Soufflés Glacés à la Reine Maud.
Friandises.

WINDSOR CASTLE. 15 Novembre, 1906.

Filet de Sole Grand-Duc (Sole fillets)

Served at the State Banquet in honour of the Entente Cordiale in 2004

10 single fillets of sole – skinless
30 crayfish (allowing a few spare)
1 fresh truffle
300 ml (½ pt) fish stock
300 ml (½ pt) of double cream
30 g (1 oz) flour
30 g (1 oz) butter
1 bunch watercress
425 ml (¾ pt) sauce cardinale
2 kg (4 ½ lb) mirepoix
2 bottles white wine
salt and pepper

Trim the sole fillets and put them onto buttered steamer trays. Eviscerate the crayfish and then cook in a court bouillon, peel the tails and make sure that there is no intestinal tract left in them. Make a light velouté sauce to cover the fish.

To serve:
Steam the fillets of sole folded in ½ until just cooked, then spoon over the velouté. Place a thin slice of truffle on top. Sauce an oval dish with the sauce cardinale, then very carefully put the fillets of sole on the oval dish and put two crayfish in-between each fillet of sole. Dress the two ends of the oval dish with buttered crayfish heads and in the centre put a nice bright green bunch of watercress.

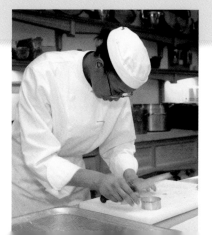

Today simple seasonal dishes are generally served, often fish and game with herb sauces and fresh green vegetables; the dessert is usually a light one.

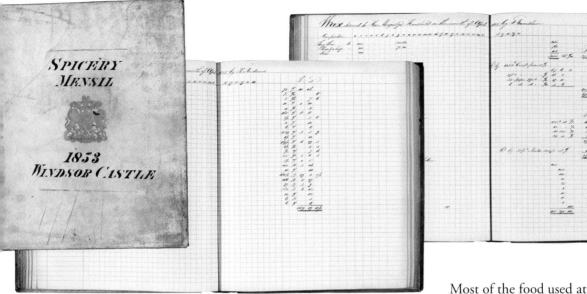

In the Royal Archives are ledgers of deliveries to the kitchens at Windsor and Buckingham Palace dating back to George IV's reign. Known as the Mensil books (from the Latin: *mensa*, a table), these record deliveries of meat, game, fruit, vegetables and spices. In 1853, for example, items such as almonds, arrowroot, cinnamon, cloves, ginger, nutmegs, sultanas, sugar and tapioca were delivered, together with capers, gherkins, isinglass (for making jellies), olives, pickled lemons, vinegar, pistachios and imitation fruits.

Most of the food used at banquets today comes from local suppliers, and where possible it is sourced from British farmers. In the autumn, venison from Balmoral is often on the menu. Until the 1980s many items were provided from the gardens and greenhouses at Windsor, established in the Home Park early in the reign of Queen Victoria. Prince Albert was instrumental in designing the hothouses which were enormously productive. By the 1890s they were producing 4,000 lb of grapes, 520 dozen peaches, 220 dozen nectarines, 180 dozen apricots, 239 pineapples and 400 melons in a single year.

The Great Kitchen at Windsor Castle is the oldest working kitchen in England – it has been in use through the reigns of 32 monarchs.

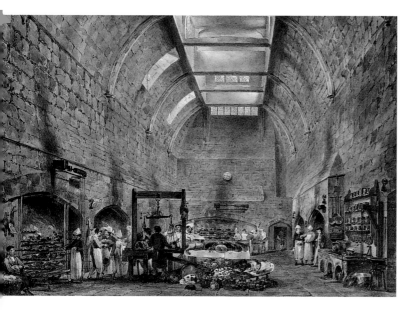

Until the fire of 1992 it was thought that the existing fabric was predominantly 17th century, but during restoration work it became clear that the current structure was created during the reign of Edward III in about 1360. The medieval oak roof beams are still in place.

During the reign of Elizabeth I the kitchens were in such a poor state that her food was cooked almost a mile away, in Peascod Street in Windsor. Renovations in the 17th century changed some areas but essentially the space remains the same. This watercolour (left) records the appearance of the kitchen under George III.

George IV undertook a rebuilding programme at the Castle and some tiling and plasterwork were added. Since then modern appliances have replaced the old open fires and ranges, but many of the tables, workbenches and shelves date from the 1820s.

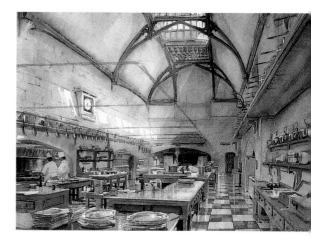

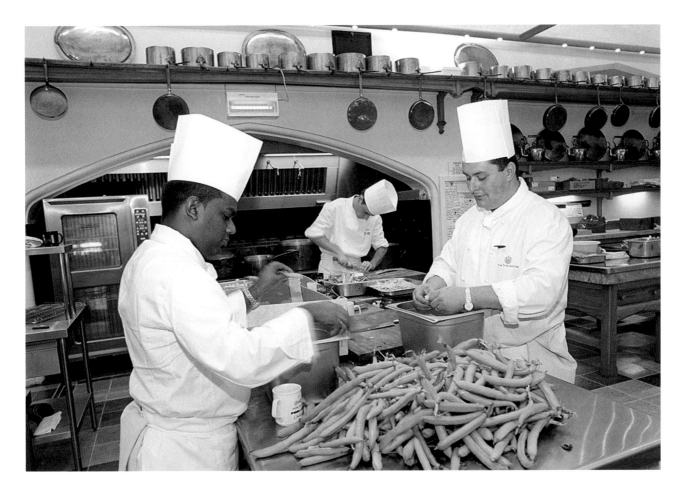

Preparation of the food for the banquet begins several days in advance of the event. A team of 20 chefs and sous-chefs work to create the meal. They also have to feed the rest of the staff in the Household, the orchestra, the pipers, the Yeomen of the Guard, security teams, medical staff and drivers.

There are 250 covers served in total. For a State Visit, an arrival lunch is usually also served. This means that additional help is required in the kitchen and extra staff, often catering students, are brought in for such occasions.

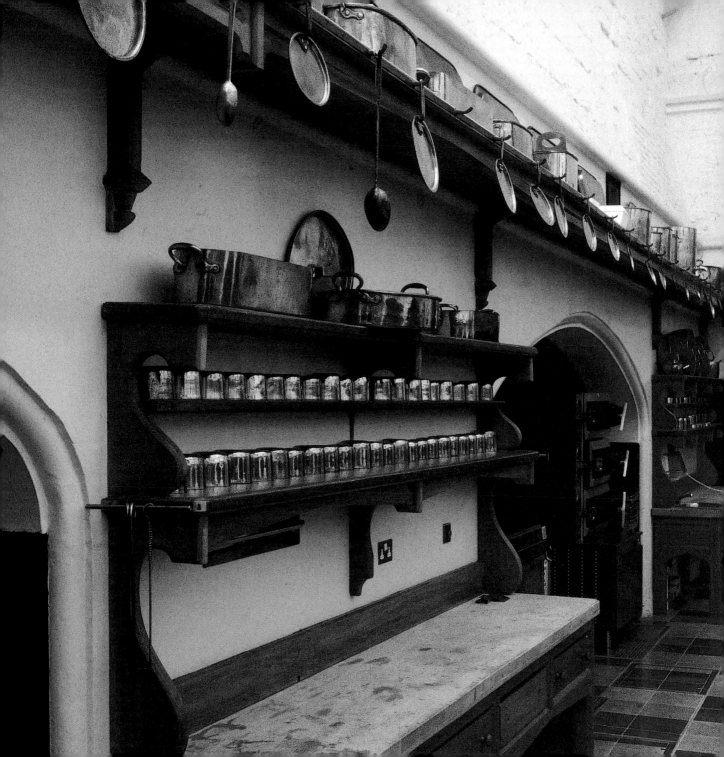

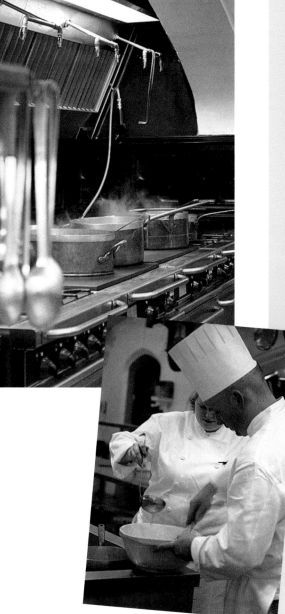

From *The Private Life of Queen Victoria*, written by one of her servants in 1897:

'… *to say nothing of the scene when a State Banquet is in progress. Then it is that under the brilliant glare of numberless gas jets, the two great open fires roar up their wide-throated chimneys, while before the fierce blaze, two score of glistening, juicy joints, all crackle and splutter. White-clad cooks hover round monstrous coppers which fill the air with the hum of their bubbling. At his desk the store-keeper checks the quantities of food in course of cooking, or sends messengers flying to the storeroom for supplementary supplies. With the monotonous jangle of the endless chains that turn the spits, mingles the noisy stoking of the many different fires and the clang of the oven doors as they are sharply opened and shut. On the gas-stoves the* bains-maries *hiss forth a most savoury steam of appetising sauces, while before their own particular blaze, fat chickens frizzle contentedly under the attentions of a roasting cook and his basting ladle.*'

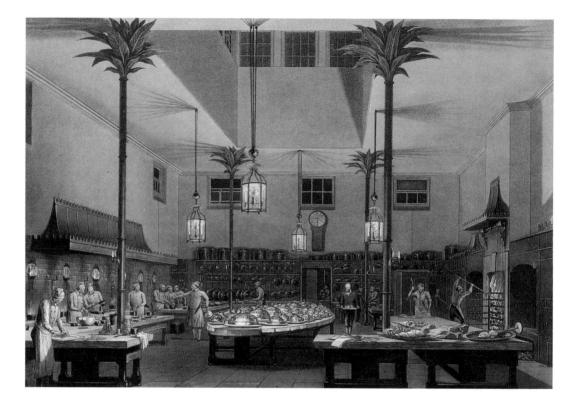

Perhaps the most famous chef to work in the royal kitchens was the Frenchman Marie Antoine (Antonin) Carême, shown above in the new kitchen at Brighton. He had worked at the Napoleonic court, and may have cooked for Napoleon himself. George IV was caricatured mercilessly for his gourmandising. Records of a ball (far right) held at his residence in 1813 show his love of playing the host: a total of 909 dishes were served.

In 1816, when he was Prince Regent, George IV invited Carême to England to serve him at Brighton and possibly at Carlton House too. Carême wrote about this period later in his life, saying 'I was there gratified; for this truly royal table was served always in the French manner, and the service of silver was so superb and elegant, that I was struck with wonder.'

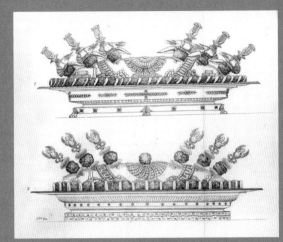

Carême (below right) was less keen on some of his English colleagues' work practices – overusing cayenne pepper, mixing flavours in an indiscriminate manner and overpricing their wine all met with his disapproval; he remained in England only six months.

For the Prince Regent Carême invented the dish *Pike à la Régence* – a pike stuffed with quenelles of smelt and crayfish butter, and dressed with truffles, crayfish tails, sole fillets and bacon. After cooking for 2 hours, this was garnished with truffles, slices of eel, mushrooms, crayfish tails, oysters, smelts, carp roes and tongues, and 10 *hâtelets* (garnished skewers) of sole, crayfish and truffles.

65

Carême was not the only French chef to work for the royal family. Since the days of Charles II there have often been French cooks in the royal kitchens. After his coronation banquet, James II set aside Patrick Lamb as master cook in favour of a Frenchman. George IV had a French Clerk of the Kitchen, the confectioner Louis Weltje (above left). He also employed François Benois, who not only cooked for the Prince but purchased many works of art from France on his behalf.

Gabriel Tschumi (opposite right), who was Swiss, was employed by Queen Victoria. He recorded in his autobiography that the Head Chef at the time of his arrival at Buckingham Palace was M. Ménager – clearly a rather formidable figure in Tschumi's eyes. For large banquets, that of the 1897 Diamond Jubilee in particular, 24 extra chefs from Paris were invited to the Palace to assist with the cooking. Tschumi noted that the younger apprentices attempted to grow their moustaches to resemble their French superiors.

King Edward VII also employed a French Head Chef – Henri Cédard – as well as an Egyptian who made Turkish coffee for royal dinner parties. Even today, the chefs work in the tradition of classical French cuisine.

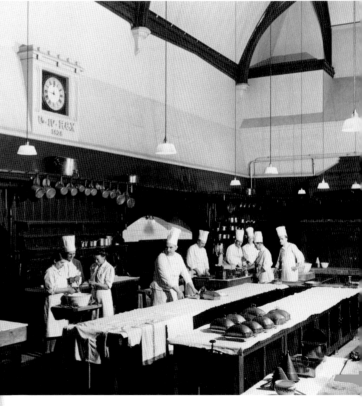

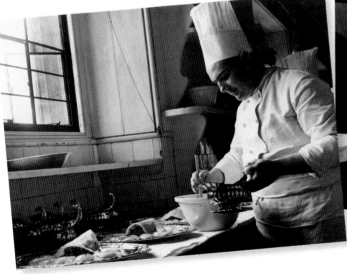

One of the oldest English recipe books, *The Forme of Cury*, was compiled by a master cook to Richard II around 1390 and contains recipes for the sophisticated and highly spiced food eaten by the English court at the time.

It includes, for example, recipes for *Cormarye* – pork marinaded in red wine with coriander, caraway and garlic – and *Tart de Bry*, filled with Brie cheese, ginger, saffron, sugar and egg yolks. *The Forme of Cury* was used by royal cooks until the reign of Elizabeth I.

Patrick Lamb published this recipe book of 'court' dishes in 1710. It contains items such as lobster soup, *venison à la royale*, 'pease stewed in the French way', and 'fry'd cream'.

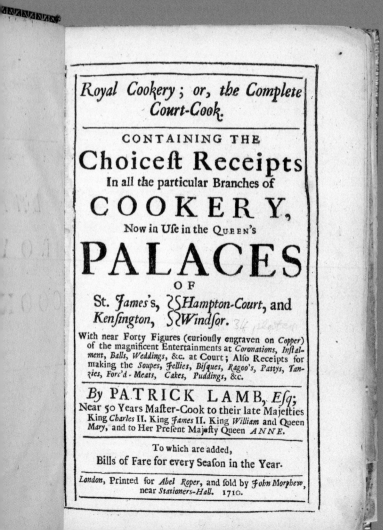

Royal Cookery; or, the Complete Court-Cook.

CONTAINING THE

Choiceſt Receipts

In all the particular Branches of

COOKERY,

Now in Uſe in the QUEEN'S

PALACES

OF

St. James's, ⎱Hampton-Court, and
Kenſington, ⎰Windſor.

With near Forty Figures (curiouſly engraven on Copper) of the magnificent Entertainments at *Coronations, Inſtalments, Balls, Weddings, &c.* at Court; Alſo Receipts for making the Soupes, Jellies, Biſques, Ragoo's, Pattys, Tanſies, Forc'd-Meats, Cakes, Puddings, &c.

By PATRICK LAMB, *Eſq*;

Near 50 Years Maſter-Cook to their late Majeſties King *Charles* II. King *James* II. King *William* and Queen *Mary*, and to Her Preſent Majeſty Queen *ANNE*.

To which are added,

Bills of Fare for every Seaſon in the Year.

London, Printed for *Abel Roper*, and ſold by *John Morphew*, near Stationers-Hall. 1710.

To ſtew Peaſe the French Way

Take Lettice, and cut them in little Bits, and three or four Onions, Slices of Bacon, a little Butter, Pepper and Salt, and toſs them over a Stove till the Lettice is hot; then add your Peaſe, and hold them ſtewing till they are tender; then add to them a little Boiling Water or good Broth: So let them ſtew ſoftly, and ſerve them with a Piece of Bacon, in the Middle of the Diſh, broil'd with Parſley and grated Bread. So ſerve it to the firſt Courſe.

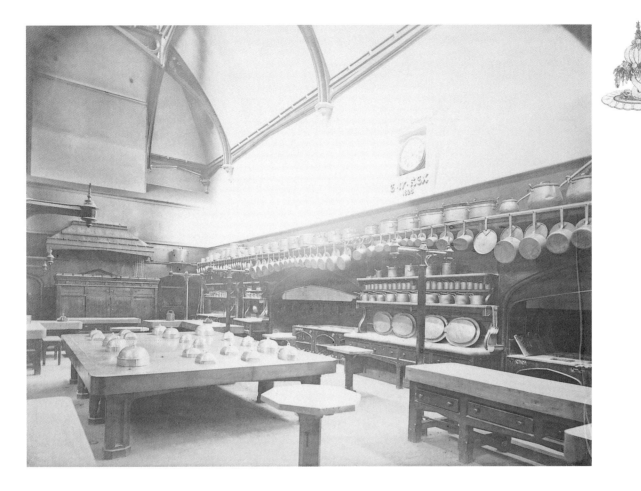

Tschumi left the following description in his autobiography: 'The Kitchens at the royal establishments, particularly those at Windsor Castle were vastly superior in every way… I remember on my first day at Windsor thinking how much the kitchen reminded me of a chapel with its high domed ceiling, its feeling of airiness and light and the gleam of copper, well worn and burnished, at each end of the room.'

Tschumi also recorded that the kitchens at Windsor were always well equipped. 'Each senior member of the kitchen staff had his own set of kitchen utensils which no one else used and which were kept clean and in good order by the kitchenmaids…' The copper *batterie de cuisine* remains in use today.

Many of the pieces date back to George IV's kitchens, and are engraved with his cipher and the name of the area of the kitchen in which they are to be used (the main kitchen, the pastry kitchen or the confectionery). The size and shape of the large coppers remain the most suitable for cooking on a large scale to this day. They are regularly re-tinned on the inside.

The Pastry Chef at Buckingham Palace is in charge of the dessert courses of the banquet. For the French banquet in 2008, she produced a *savarin à la rhubarbe* and *crème vanilla*.

The word 'banquet' was originally used to describe the dessert course but has come to mean any grand or lavish meal. Dessert was originally the most expensive course of the meal as the exotic spices for flavouring and the sugar for sweetening were all imported. The 'banquet' course was always considered the chef's chance to show off his skills in creating decorative dishes.

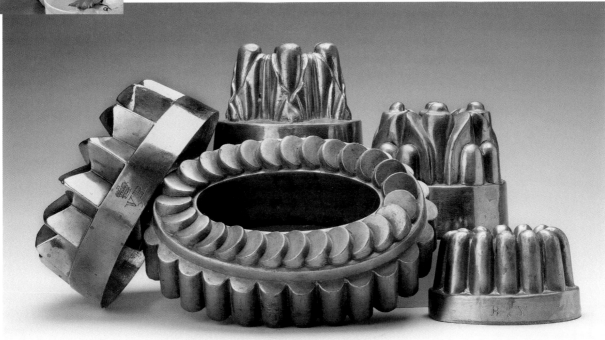

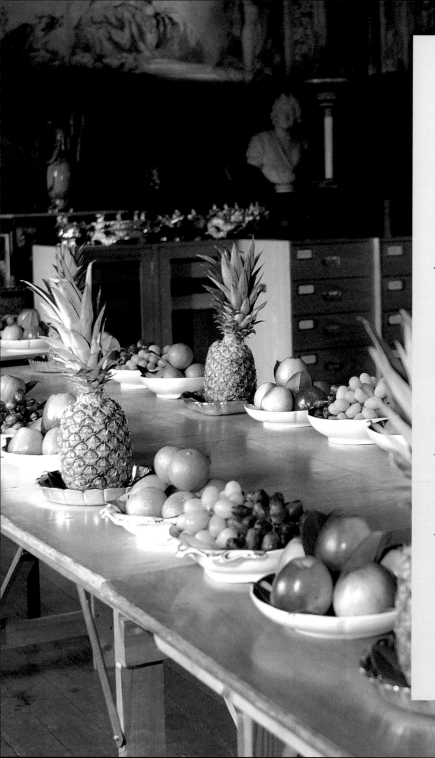

A Banquet held for George III at Windsor was described in contemporary newspapers:

'The ornamental parts of the confectionery were numerous and splendid. There were temples four feet high, in which the different stories were sweetmeats. The various orders of architecture were also done with inimitable taste... the dessert comprehended all the hothouse was competent to afford – and, indeed, more than it was thought art could produce at this time of year. There were a profusion of pine[apple]s, strawberries of every denomination, peaches, nectarines, apricots, cherries of each kind, from the Kentish to the Morella, plums and raspberries, with the best and richest preserved fruits, as well as those that are in syrup.'

Carême decorated the table with structures resembling architectural follies and ruins, using any material available – from icing sugar and confectioner's paste to cardboard, wood, glass, silk, sugar, powdered marble, wax and coloured butter.

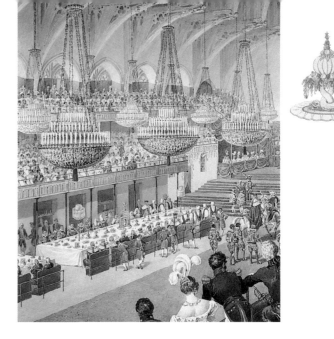

Pl. 61.

Le Temple antique sur un Rocher.

The accounts for the decoration of the banqueting table at George IV's coronation include a detailed carpenter's bill for a large ornamental temple for the table with eight reeded columns and four circular pedestals for figures at the angles, with four entablatures over to support a dome. The wooden structure would have been decorated with sugar and marzipan and further edible items. Indeed, after the King had left the banqueting table, the guests destroyed all the edible parts of the decoration in their desire to keep a souvenir of the event.

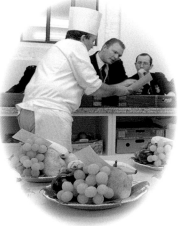

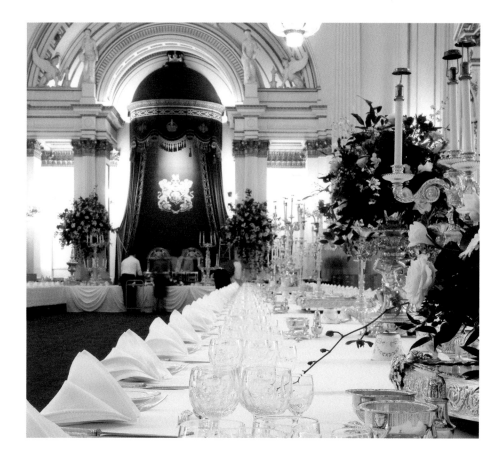

STATE BANQUET 13th May 1958

DESSERT FRUIT ARRANGEMENT

Fruit	Top Table 12 Green Sevres	8 Round Tables 24 Blue Sevres (on Stands) 3 Dishes per Table	8 Round Tables 16 Green Sevres 2 Dishes per Table	Sideboards 10 Dishes 3 on each	Total Pieces
GRAPES	3 x 1	8 x 1	8 x 1		19 Bunches
PEACHES	3 x 6	8 x 7	8 x 9 (8 x 6)		122
APPLES	3 x 6	8 x 7 (4 x 7)	(8 x 3)	3 x 6	88
PEARS	3 x 6	8 x 7 (mixed)(4 x 7)	8 x 3 (with Grapes shown above)	1 x 6	76
BANANAS	-			3 x 1	3 Hands
ORANGES	-			3 x 5	15
	12 Dishes	24 Dishes	16 Dishes	10 Dishes	

Today flowers and fruit are used instead. The Queen's tables are always set with decoratively piled fruit. Lists of fruit and where it was to be placed can be found amongst the records of previous banquets – this one dates from 1958 and was for the visit of President Gronchi of Italy.

Mildred Nicholls was first employed as the seventh kitchen maid at Buckingham Palace in 1907, and by 1919 when she left service she had risen to number 3 in the hierarchy. Her handwritten notes on the recipes used by the pastry chefs include Royal Plum Pudding, *crème à la Carême*, *Pouding Soufflé à la Royale* (shown here) and a Danish dish known as *Rodgröd*. This was one of Queen Alexandra's favourite dishes and was made with redcurrants and other berries. It was often served at post-theatre supper parties in Buckingham Palace.

Receipes

Mildred. D. Nicholls
Pastry
Buckingham Palace.
London.

Pouding Soufflé à la. Royale.

Cold Genoise Souffle au Citron. Apricot
Sauce
Make Genoise in ordinary way with
exception of Baking Powder. 1 lb is
sufficient for 4 Baking Sheets.
When just begining to set. take
out of oven, spread with Black or Red
currant Jelly & roll. When cold cut
into thin Slices & stick round a
well Buttered Souffle Mould.
fill up with Souffle & Bake in
Bain Marie in oven for 30 to 45
Minutes. Slow oven to start
Serve with apricot Sauce or
Raspberries f.ce flavored with a
little Vanila

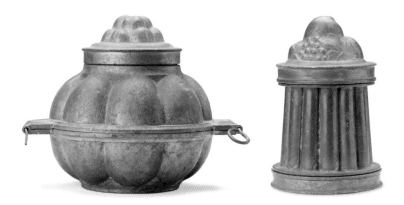

Iced desserts have always been popular at banquets, despite the problems of keeping them cold in the days before electrical refrigeration. Gabriel Tschumi recorded daily deliveries of ice to the Palace to keep items cool. At Windsor and at Balmoral this ice came from the ice-houses in the grounds.

The first recorded mention of ice cream in England is in a menu for Charles II's Garter Banquet in 1671. At this date it was probably no more than frozen cream – possibly flavoured. It was created using a bucket of ice mixed with salt or saltpetre, which enhanced the freezing properties.

The flavoured cream would be placed in a watertight container that was plunged into the bucket. This would be intermittently turned and agitated to ensure every part of the cream was frozen.

The historic pewter and copper moulds for ice-cream bombes show that ices remained popular at the Palace. The Queen chose *bombe glacée Princesse Elizabeth* for her Wedding Breakfast.

GRE

BUCKINGHAM PALACE
THURSDAY, 20TH NOVEMBER, 1947
WEDDING BREAKFAST

Filet de Sole Mountbatten

Perdreau en Casserole
Haricots Verts Pommes Noisette
Salade Royale

Bombe Glacée Princesse Elizabeth
Friandises

Dessert

Café

Charles Francatelli (below), who was Queen Victoria's confectioner, developed a recipe called *Iced Pudding à la Victoria*. It consists of a *plombière* ice of cream, almonds, bitter almonds, orange-flower water, sugar, apricot jam, eggs and meringue, mixed with dried apricots, dried cherries, *diavolini* candies and double cream. This was frozen in a melon-shaped mould, sprinkled with chopped almonds toasted to a light brown colour and chopped pistachios (these are intended to have the rugged appearance of the peel of the melon) and garnished with small fancy fruit-shaped ices. Francatelli served it on a stand of coloured water frozen in a mould of entwined dolphins.

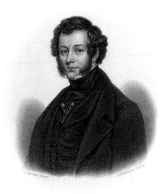

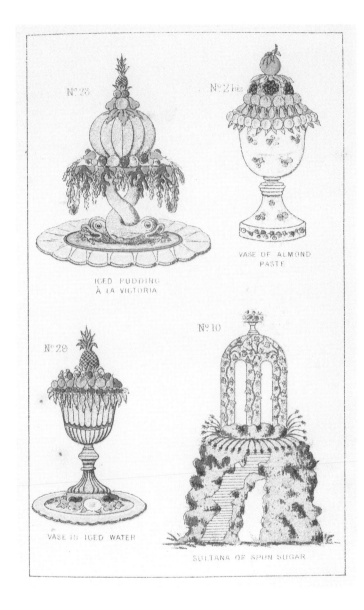

N.° 23

ICED PUDDING
À LA VICTORIA

N.° 2 bis

VASE OF ALMOND
PASTE

N.° 29

VASE IN ICED WATER

N.° 10

SULTANA OF SPUN SUGAR

Pouding d'Ananas à la Royale

Take 2 medium pineapples, peeled, sliced and diced; boil for 10 minutes in 6 oz of sugar in syrup. Cut the peel in dice also and put them into a pint of boiling cream; infuse for 10 minutes, add 6 oz sugar, 12 egg yolks and thicken over a slow fire, then sieve. When cold add the syrup and freeze.

Afterwards add the pieces of pineapple, with half a pot of preserved cherries drained and washed, 2 oz of pistachio kernels cut into fillets, and 2 rich pears cut into large dice; when well mingled add a plateful of whipped cream; again freeze it and mould it. Leave it an hour in the ice, and serve on a napkin.

Antonin Carême
Master Cook to George IV

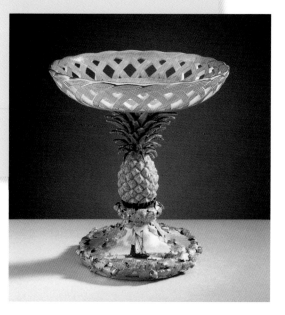

Pineapples make a particularly decorative feature with their hint of the exotic. At the Palace, they have always played a large part in the dessert course. Charles II is shown in the painting here receiving a pineapple from one of his gardeners. For a time this painting was thought to represent the first pineapple grown in England, but in fact it is too early for this to be the case. The fruit must instead have come from the West Indies.

John Evelyn, who waited on the King at a banquet held for the French Ambassador in 1668, recorded in his diary that the King offered him a taste of a pineapple from his own plate. Evelyn was rather disappointed with the taste, saying 'It has a grateful acidity but tastes more of the quince or the melon.' He excused its flavour, attributing it to the distance the fruit had travelled.

Pineapples are represented in the silver and porcelain services created for George IV and William IV respectively.

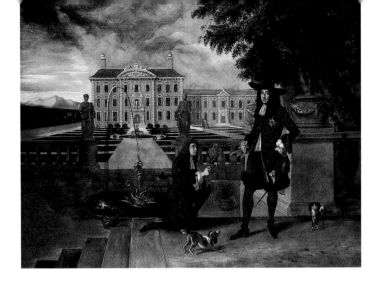

George IV's coronation banquet, held in Westminster Hall, London, also featured pineapples. The menu (below) of the third course of the dinner shows that the pineapple was placed directly in front of the King during the meal. The Earl of Denbigh, who waited on him, records in his description of the banquet that 'Lord Colchester was my assistant carver and cut up a pineapple weighing 11 pounds.'

Today pineapples placed on the table during banquets are carved in advance of the meal; the slices are then hidden inside the intact shell so that they decorate the table for the first three courses. During the final course the shell is removed and guests are offered slices.

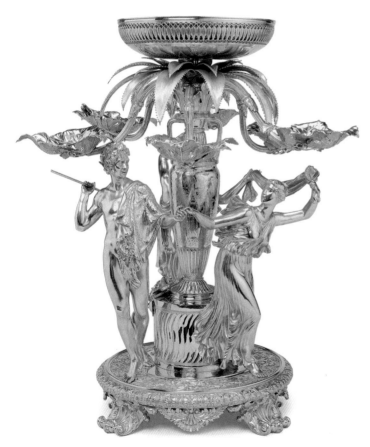

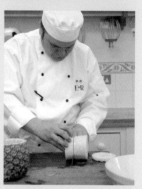

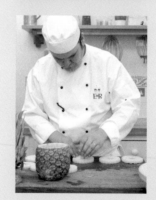

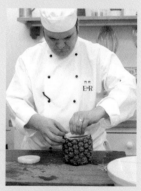

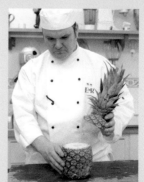

The Pastry Chef is also responsible for the *petits fours* served with coffee, in the Music Room, State Dining Room and Blue Drawing Room at Buckingham Palace, and in the Crimson and Green Drawing Rooms at Windsor Castle. The *petits fours* include both chocolates and *pâtes de fruits*, and roughly 350 are needed, served on beautifully decorated silver-gilt plates. For the visit of the King of Saudi Arabia in 2007, a selection of chocolate leaves, inspired by the autumnal trees in nearby Green Park, was also created. The chocolate leaves were bronzed with edible powder, and chocolate twigs were added to the display.

National tastes are also reflected. For the Saudi Arabian visit, the truffles were flavoured with cardamom; while for the visit of President Kufuor of Ghana in 2006, Ghanaian chocolate was used.

Icing-sugar flags of the visiting nations have also been used as decoration.

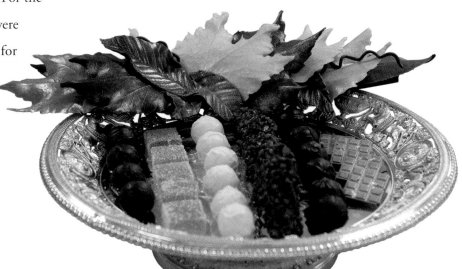

Parfait au chocolat et framboises
(Chocolate and raspberry parfait)

200g (7oz) good-quality dark chocolate
250g (9oz) fresh raspberry purée
2 pasteurised egg yolks
1 pasteurised whole egg
100g (3 ½ oz) caster sugar
300ml (½ pt) whipping cream

Place chocolate in a bowl and place over a saucepan of simmering water to melt (or you can use a microwave). Using an electric mixer, whisk the egg yolks, whole egg and caster sugar to a stiff sabayon before quickly adding the warm chocolate. In a separate bowl whisk the whipping cream and raspberry purée to a ribbon stage. Finally, very carefully fold the chocolate sabayon mix and the semi-whipped cream mix together, ensuring that they are not over-mixed.
Pour into desired moulds and allow to freeze until firm.

At Buckingham Palace these are served wrapped in white chocolate and garnished with fresh whole raspberries, rolled in a raspberry coulis.

Served at Buckingham Palace, May 2008

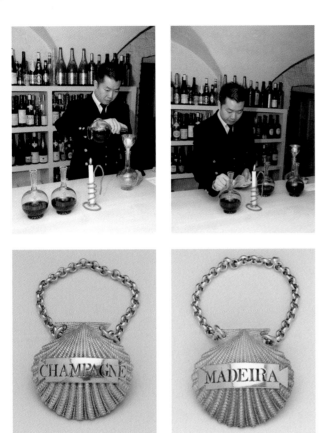

They are divided into carefully defined areas – for private use and for official entertaining. The wine for State Banquets is drawn from the latter. Wine that has been presented to various members of the Royal Family as gifts is also stored here. There are 25,000 bottles of wine and spirits housed in the cellars, including four bottles of Malmsey dating back to 1850, and a bottle of sherry from 1660. A further 5,000 bottles are stored in Windsor Castle.

The cellars in Buckingham Palace are part of the oldest section of the building, dating back to around 1700. They are kept at a constant cool temperature (about 10°C) using water from a bore-hole in the grounds of the palace. The water then empties into the lake in the grounds.

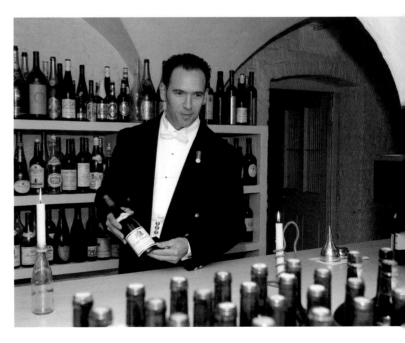

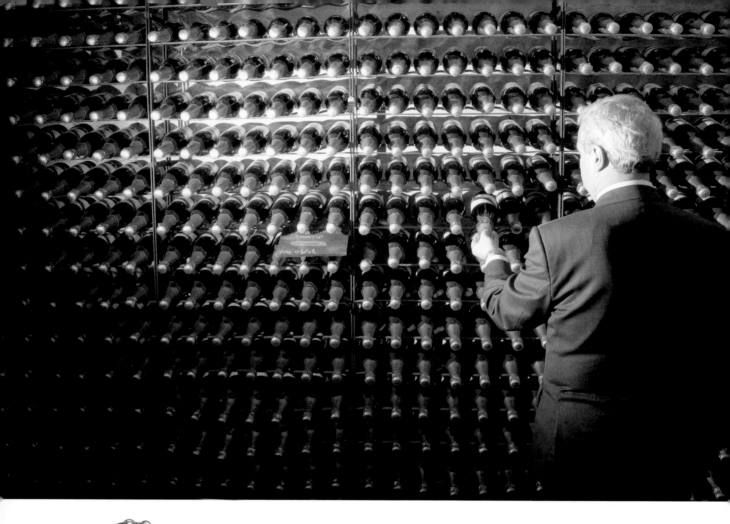

The Yeoman of the Cellars is advised on the wine menu by the Royal Clerk of the Cellars. Two bottles of wine are allocated per ten guests.

Two different champagnes are provided – one for toasting and one to accompany pudding. Until the 13th century only English wine was served at court. Today a mixture of Old and New World wines features on the menu.

On the day of the banquet, the staff of the cellars decant the red wine into glass claret jugs, and port into glass decanters, using Edwardian silver funnels. Silver-gilt wine labels are placed around the necks of the port decanters. These are drawn from the Grand Service and reflect the changing taste in wines over the years. As well as port, champagne and claret, there are also labels for pink champagne, Hermitage and Tokay. The Yeoman of the Cellars always serves The Queen at a banquet.

Elderflower Wine

To 12 gallons of water put 30 lbs of loaf sugar; boil it till two Gallons are consumed, scuming it well. Let it stand till it be cool as wort; then put in two or three spoonsful of Yeast. When it works put in two Quarts of Elder Flowers pick'd from the Stalks, stirring it every Day till it has done working; then strain it and put it into a Vessel. After it is stopt down let it stand till it is fine, and then bottle it.

Mary Eales, Confectioner to William III and Queen Anne

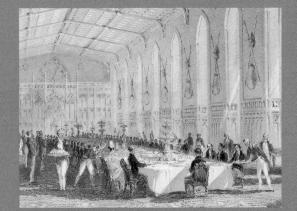

the Ceremony

The gilt-edged invitations for a State Banquet are sent out by the Master of the Household's Department, one of the five departments of the Royal Household, twelve weeks before the event. Guests include the Royal Family, the visiting Head of State and their suite, members of the Cabinet, the Archbishop of Canterbury, the Speaker of the House of Commons, leaders of the main political parties, the Governor of the Bank of England, and special guests whose work or background links them to the visiting nation.

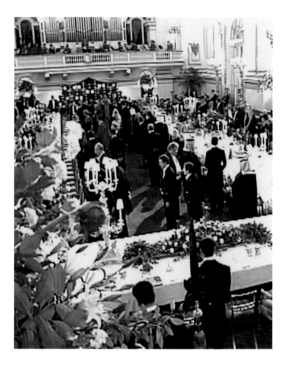

The Lord Steward
has received Her Majesty's command to invite

..

..

to a State Banquet to be given at Windsor Castle by
The Queen and The Duke of Edinburgh
in honour of The President of the French Republic
and Madame Nicolas Sarkozy
on Wednesday, 26th March, 2008 at 8.30 p.m.

A reply is requested to:
The Master of the Household,
Buckingham Palace,
London SW1A 1AA.

Evening Dress (White Tie),
Decorations,
Full Ceremonial Evening Dress for
Serving Officers, or National Dress

Guests are asked to arrive at Windsor Castle between 7.50 and 8.10 p.m.

Guests are expected to wear full evening dress (long dresses for the ladies, white tie for the gentlemen), or national dress. Members of The Queen's Household wear a special navy blue tailcoat with velvet facings. At Windsor some members of the Household are invited to wear the Windsor Coat – a dark blue coat with red facings to the collar and cuffs.

On arrival, each guest is presented with a booklet. This contains a list of all the guests, a menu and wine list, the music to be played by the orchestra and the pipers, and a seating plan with a coloured dot to indicate to the guests where they are to sit. These booklets are decorated with a coloured ribbon representing the national colours of the visiting nation. For the visiting suite, books with details of the entire visit are prepared. These have covers which also relate to their national colours.

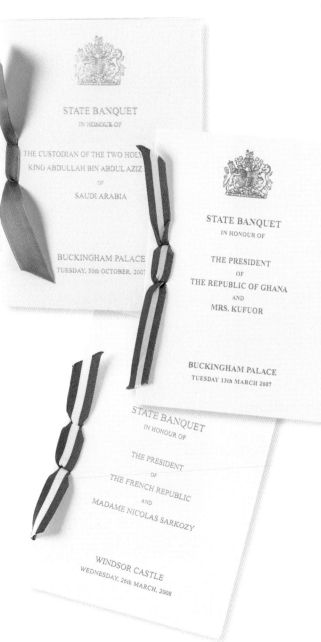

The seating plan is worked out by the
Master of the Household's Department,

**STATE BANQUET
WEDNESDAY 26th MARCH 2008**

**ST. GEORGE'S HALL
WINDSOR CASTLE**

Air Vice-Marshal David Walker

Miss Sara Thornton — Mrs. Downes
Mr Andrew Marr — Mr Nick Lander
Ms Sarah Gillett — Mr Doug King
Monsieur Frank Lavender — The Hon. Lady Roberts
Mrs. Naomi Brauiler — Mr Clive Alderton
Mr. Kevin Harris — The Hon. Jackie Ashley
Lady Figgis — Monsieur Eric Tailliez
Mr. Gilbert Houalla — The Hon. Mrs. McDonald
Mrs. Faike Iminger — Sir Philip Wroughton
Monsieur Cédric Gouhot — Mr Westmacott
Sir Mark Lyall Grant — Doctor Richard Corbett, MEP
Madame Ludovic de Montille — Mr Ross
The Duke of Abercorn — Air Chief Marshal Sir Glenn Torpy
Lady Wroughton — Madame Marisa Davini-Trabucchi
The Rt. Hon. Christopher Geidt — Monsieur Jean-Laurent Dupont
Lady Markowitz — **PRINCE MICHAEL OF KENT**
THE DUCHESS OF GLOUCESTER — Mr Alice Perkins
Monsieur Jean-David Levitte — Professor Sir Basil Markesinis
The Rt. Hon. the Baroness Quin — Lady Bell
Mrs. Cameron — The Rt. Hon. the Earl Peel
The Ambassador of Belgium — Monsieur le Préfet Bernard Squarcini
Lady de Rothschild — The Lady Myreeou
The Rt. Hon. the Speaker — Major General Bill Cubitt
The Lady Vestey — The Secretary of State for the Home Department
The Ambassador of the Federal Republic of Germany — Monsieur Jean-Laurent Dupont
Lady Llewellyn Smith — **VICE ADMIRAL TIMOTHY LAURENCE**
The Lord Archbishop of Canterbury — The Leader of the House, Lord
THE DUKE OF YORK — The Rt. Hon. the Baroness Ashton of Upholland
Madame Sonia Yade — The Ambassador of Italy
The Secretary of State for Foreign and Commonwealth Affairs — Mr. Richard Brown
Mr. Peter Kellner — The Rt. Hon. the Lord McNally
THE PRIME MINISTER — Mrs. Riskill
Madame Rachida Dati — Admiral Edouard Guillaud
Professor Sir Chris Llewellyn-Smith — Mr. Richard Brown
THE DUKE OF EDINBURGH — The Rt. Hon. the Lord Davies of Oldham
MADAME NICOLAS SARKOZY — Mr. Martin Hayman
THE PRINCE OF WALES — Bajeurs Artagnes
Mrs. Williams — Sir Howard Davies
The Ambassador of the State of Kuwait — The Lord Chancellor and Secretary of State for Justice
Mrs. Darling — **THE DUCHESS OF CORNWALL**
The Viscount Brookeborough — **THE PRESIDENT OF THE FRENCH REPUBLIC**
Mrs. Cubitt — **THE QUEEN**
Monsieur Ludovic de Montille — Monsieur Bernard Kouchner
The Rt. Hon. the Lord Speaker — **THE PRINCESS ROYAL**
THE EARL OF WESSEX — Air Chief Marshal Sir Jock Stirrup
Madame Nicole Amelius — The Lady McNally
The Chancellor of the Exchequer — The Lord Vestey
Dr. Jean-Pierre Garnier — The Countess of Caux Miranda
The Countess Peel — The Rt. Hon. the Lord Davies of Oldham
Mr. Jean Castkille — Mr. Nicolas Moreau
Monsieur Henri Guaino — The Rt. Hon. David Cameron, MP
The Lady Susan Hussey — The Viscountess Brookeborough
The Rt. Hon. Nick Clegg, MP — The Ambassador of Spain
Sir Kevin Smith — Mrs. King
Ms Amlia Gartvzell-Haylam — Sir Evelyn de Rothschild
THE DUKE OF KENT — Mr. Milband
The Lady Seaman — The Ambassador of the French Republic
The Secretary of State for Business Enterprise and Regulatory Reform — **THE DUKE OF GLOUCESTER**
Sir Stuart Bell, MP — Mrs. Gordon Brown
Madame Catherine Pegard — The Ambassador of the Republic of Slovenia
Sir Peter Westmacott — The Lady Davies of Oldham
Mr. Richard Smith — Surgeon Vice-Admiral Ian Jenkins
The Hon. Mrs. Legge-Bourke — Lady Stirrup
Monsieur Fabien Raynaud — Mr Simon McDonald
Sir Anthony Figgis — Monsieur Jean-Pierre Aevzandovrien
Mrs. Corbett — **PRINCESS MICHAEL OF KENT**
Sir Hugh Roberts — Professor Mervyn King
Ms Jancia Robinson — Ms Miriam González Durantez
Mr. Marr Beche — Sir Peter Ricketts
Lady Hunt-Davis — Mr. Justuce Harris
Mr. Michel Barza — Brigadier Sir Miles Hunt-Davis
Mrs. Yuiquit — Dame Ellen MacArthur
Brigadier John Smedley — Mr. Raphael Downes
The Hon. Mrs. Whitehead — Mr. Anthony Mayhew — Mr Frsa Kenly
Squadron Leader Andrew Calame RAF — Mr. Jonathan Spencer — Mr. Dolphinc Consed
Lieutenant-Colonel Siegfried Ural

Lieutenant-Colonel Andrew Ford

ENTRANCE — FIRE PLACE — EXIT — EXIT — WINDOWS

**Buckingham Palace
Dinner List
Tuesday June 28th 1853**

In honour of the Christening of the Infant Prince, 4th Son of Her Majesty & His R.H. the Prince Albert

In the Picture Gallery

8 o'clock Precisely

The Queen

[handwritten guest list continues in two columns, largely comprising Royal Highnesses, Their Serene Highnesses, Ladies in Waiting, and household officers]

using a leather model of the table with slots
for each guest. It often takes several hours
to complete the full plan, and last-minute
changes can occur. The Queen always approves
the final arrangement. Individual place cards
are then printed and are placed on the table
during the afternoon before the banquet.

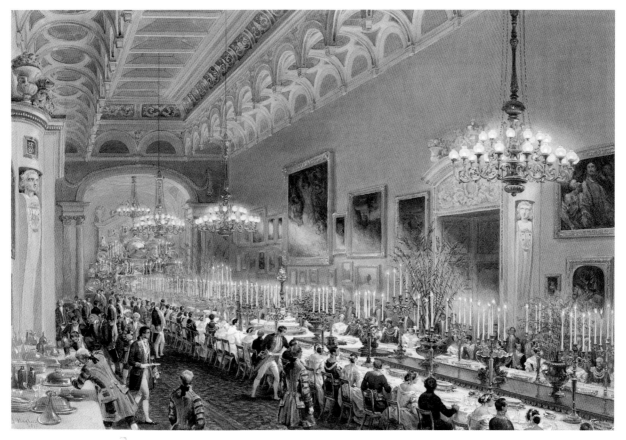

Queen Victoria's staff recorded the guests at every meal during her reign. The guest list for the banquet held to celebrate Prince Leopold's christening in June 1853 is shown opposite. This took place in the Picture Gallery of Buckingham Palace at a single long table (above). The guests included the King and Queen of Hanover. The menu offered turbot, salmon, calves' heads, turkey, quail, lobster mayonnaise and champagne jelly with strawberries. The table, a blaze of candlelight, and with the Grand Service gleaming along its length, no doubt looked spectacular, but Queen Victoria in her Journal only commented on those who sat next to her at dinner, and noted that it was particularly hot.

Before a State Banquet, guests are presented to The Queen and The Duke of Edinburgh and the State Visitors. An official photograph is usually taken. Meanwhile, last-minute touches are being made to the banqueting table – the candles are lit and their shades put in place, the lights are dimmed and the orchestra begins to play. The guests are shown to their seats, while the Royal Procession forms. The Queen and visiting Head of State are accompanied by The Duke of Edinburgh and other members of the Royal Family and the visiting suite.

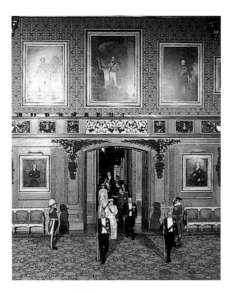

The procession is led by the Lord Chamberlain and the Lord Steward, each carrying his white Wand of Office. This tradition dates back to the reign of Queen Victoria, who always entered the banqueting room in advance of her guests, but was preceded by the Lord Chamberlain and Lord Steward walking backwards.

The Lord Chamberlain

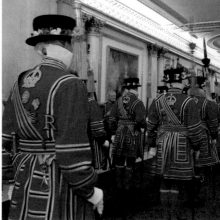

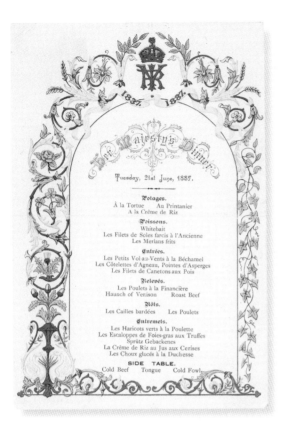

Her Majesty's Dinner.

Tuesday, 21st June, 1887.

Potages.
À la Tortue Au Printanier
À la Crème de Riz

Poissons.
Whitebait
Les Filets de Soles farcis à l'Ancienne
Les Merlans frits

Entrées.
Les Petits Vol-au-Vents à la Béchamel
Les Côtelettes d'Agneau, Pointes d'Asperges
Les Filets de Canetons aux Pois

Relevés.
Les Poulets à la Financière
Haunch of Venison Roast Beef

Rôts.
Les Cailles bardées Les Poulets

Entremets.
Les Haricots verts à la Poulette
Les Escaloppes de Foies-gras aux Truffes
Sprütz Gebackenes
La Crème de Riz au Jus aux Cerises
Les Choux glacés à la Duchesse

SIDE TABLE.
Cold Beef Tongue Cold Fowl

At every banquet The Queen's Bodyguard of the Yeomen of the Guard, in full uniform and carrying halberds, are placed around the room. They guard the entrances to the Ballroom or St George's Hall, while two further Yeomen stand behind The Queen during the meal. The Yeomen are the monarch's personal bodyguard and their presence dates back to medieval times.

They can be clearly seen in the watercolour (below) depicting Queen Victoria's Golden Jubilee banquet in 1887. Held in the Ball Supper Room at Buckingham Palace, a table was placed in the centre of the room, and flanked by two large buffets of gilt plate. The menu included turtle soup, whitebait, sole, quail, lamb, venison and beef. In her Journal Queen Victoria wrote: 'All the Royalties assembled in the Bow Room, & we dined in the Supper Room which looked splendid with the Buffet covered with the gold plate. The table was a large horseshoe one, with many lights on it.'

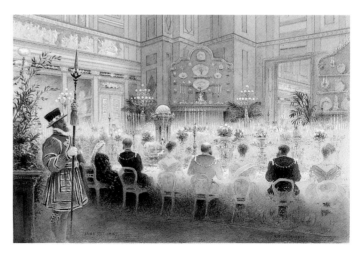

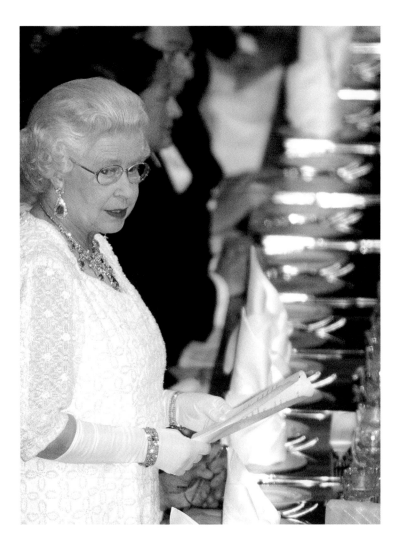

Speeches of this kind form an essential part of the diplomatic nature of these visits, and are designed to cement international relations.

Sir Frederick Ponsonby, who was equerry to King Edward VII, described a visit to France in 1903, where the French President made a speech. 'He was obviously nervous and had pinned the speech to one of the candlesticks in front of him, which necessitated his leaning forward to read it. The result was that only a certain number of people near him could hear what he said. When he had finished the King got up and replied in French. He never seemed at a loss for a word and without any notes or paper in his hand he made an admirable speech, speaking like a Frenchman, which captivated all the guests.'

Once the Royal Procession has arrived at the table, The Queen rises to give a short speech welcoming her guest. At its conclusion and before the toast, the National Anthem of the visiting nation is played.

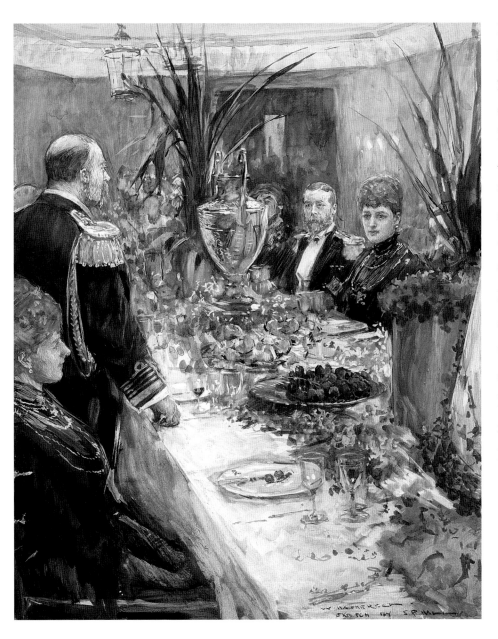

Here King Edward VII is speaking on board the yacht HMS *Ophir* on a visit to Australia and New Zealand in 1901. Among the guest are Queen Alexandra and the Duke and Duchess of York (later King George V and Queen Mary). Diplomatic dinners were given throughout the voyage at Gibraltar, Malta, Port Said, Colombo, Singapore and Mauritius.

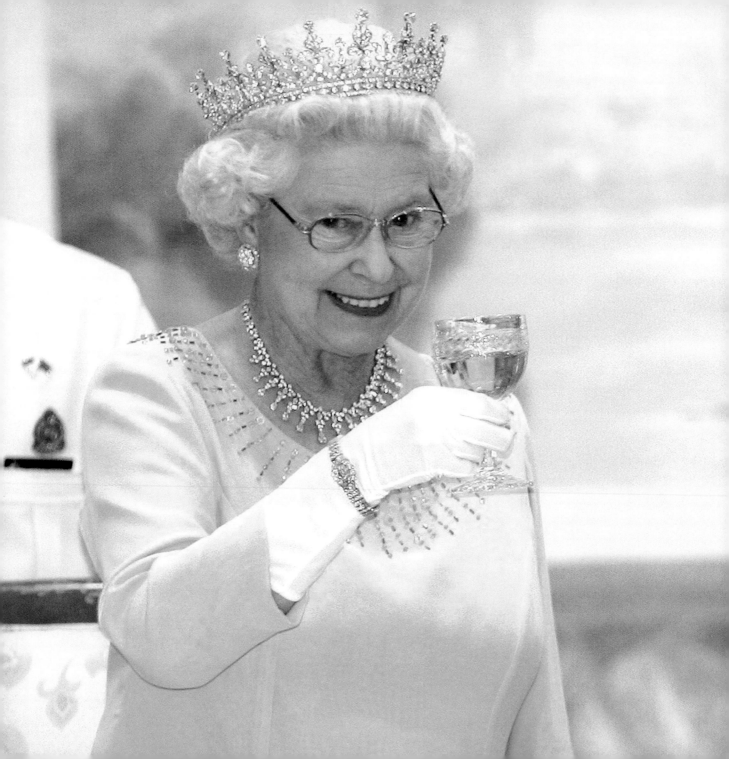

The speech is usually completed with a toast from The Queen.

An elaborate diagram for moving the relevant glass is provided by the Yeoman of the Cellars for those under-butlers who are not familiar with the sequence.

The toast is another traditional part of the ceremony, as can be seen in this hand-coloured print of Queen Victoria at her coronation banquet at the Guildhall in London in 1837. The Queen has risen to toast the City of London.

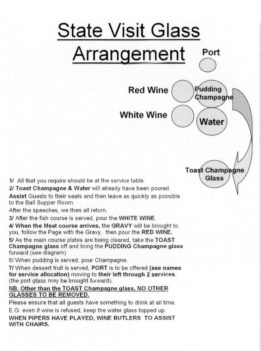

State Visit Glass Arrangement

Port

Red Wine — Pudding Champagne

White Wine — Water

Toast Champagne Glass

1/ All that you require should be at the service table.
2/ **Toast Champagne & Water** will already have been poured.
Assist Guests to their seats and then leave as quickly as possible to the Ball Supper Room.
After the speeches, we then all return.
3/ After the fish course is served, pour the **WHITE WINE**.
4/ **When the Meat course arrives, the GRAVY** will be brought to you, follow the Page with the Gravy, then pour the **RED WINE**.
5/ As the main course plates are being cleared, take the **TOAST Champagne glass** off and bring the **PUDDING Champagne glass** forward (see diagram)
6/ When pudding is served, pour Champagne.
7/ When dessert fruit is served, **PORT** is to be offered **(see names for service allocation)** moving to **their left through 2 services**. (the port glass may be brought forward).
<u>NB. Other than the TOAST Champagne glass, NO OTHER GLASSES TO BE REMOVED.</u>
Please ensure that all guests have something to drink at all time.
E.G. even if wine is refused, keep the water glass topped up.
WHEN PIPERS HAVE PLAYED, WINE BUTLERS TO ASSIST WITH CHAIRS.

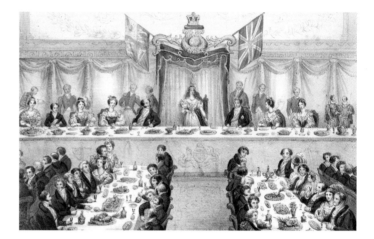

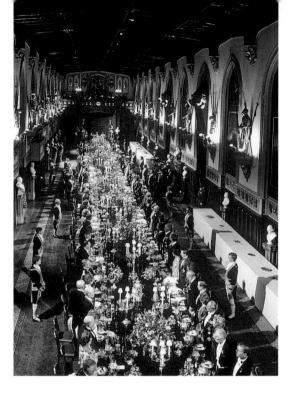

Once the guests are seated, the meal commences. The banquet is served by almost a hundred people, all co-ordinated by the Palace Steward. The service must be seamless, and perfectly choreographed by the staff. The roles of each member of staff are clearly defined. The footmen, in their red and gold uniforms, deliver the food to the servers. The pages, wearing dark blue livery, serve the guests. Each team is briefed before the banquet so that they know the sequence of courses and approximately how long each one will take. During the meal, the Palace Steward uses a system of 'traffic lights' which are set behind the scenes so that those serving the food are aware of timings. When a blue light is pressed, this means 'stand by'; an amber light indicates it is time to serve. Clearing the table takes place constantly, as each guest finishes eating. Plates are removed through a different door, so that clean and used plates are never muddled.

The wine butlers remain throughout the meal to serve the wine and drinks. Sir Roy Strong, who attended a banquet in 1976, summed up the whole spectacle: 'Then came the banquet, which resembled a ballet in which footmen bore and swept away course after course, two on gold plate and two more on Sèvres eighteenth-century porcelain of quality to make the French eat their hearts out, turquoise and gold for the pudding, dark blue and gold for dessert.'

Several of Queen Victoria's pages and footmen were photographed in the 1860s. Some of these men had started service under her uncle William IV. For many the role of footman or page was one for life.

Notes for the footmen on duty traditionally recorded that: 'Trays must be kept level so that there is no spilling of gravy or sauces – Do not attempt to hurry when carrying a loaded tray.' This was particularly difficult at Windsor, where every dish had to be carried up narrow stairs from the Great Kitchen to St George's Hall. The chefs always made twenty extra dishes for each course in case of spillage. Since the restoration of the Castle after the fire of 1992, access from the kitchens to St George's Hall has been greatly improved.

W. Collins 1866

D. Hill 1864

A. Brown.

C. Andrews.

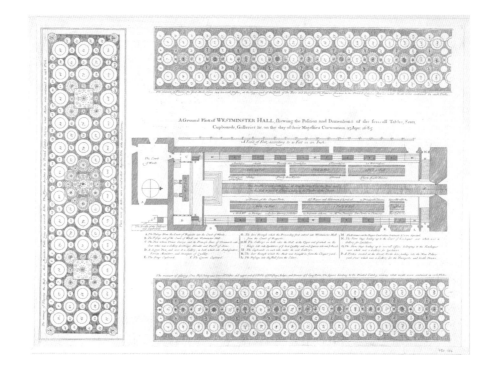

A Ground Plot of WESTMINSTER HALL, shewing the Position and Dimensions of the severall Tables, Seats, Cupboards, Galleries &c. on the day of their Majesties Coronation. 23 Apr. 1685

One essential change in the banquet is the way in which food is served. Not only has the number of courses been reduced greatly, so has the system of serving. Until the late 19th century, banquets were served in a style known as *service à la française*. This involved placing numerous dishes on the table at the beginning of the meal, arranged in a symmetrical pattern, so that diners could help themselves to the food. A range of dishes was available to everyone, but nobody was expected to try everything set in front of them. Perhaps the most spectacular example of this service was James II's coronation banquet, where 145 dishes were placed on the table for the first course. Some of these would be removed for later courses, to be replaced by further dishes. *Service à la française* was a more informal way of dining, with guests helping themselves and their neighbours to the dishes available, but it was difficult to keep the food warm throughout the meal.

In the 19th century this system was gradually replaced by one in which each course was served singly in succession. This system is known as *service à la russe* after Prince Kourakine, the Ambassador of Tsar Alexander I, who seems to have introduced it in France. This style of service meant that the courses remained hotter, and that there was far more space on the table, but a larger quantity of glass and cutlery and more labour were required. Food and drink were now served by the staff, leaving the centre of the table for decorations of flowers, fruit and other confections.

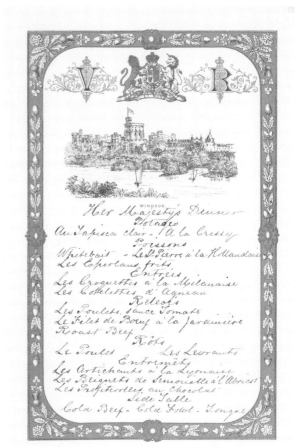

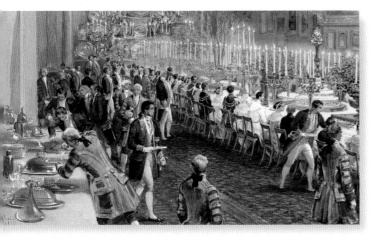

The English court was slow to adopt this new way of serving. Even in the later 19th century there were more dishes available than those served to each diner, and Queen Victoria's menu books show that there were always further roasts available on the sideboard.

The change in the manner of serving the meal meant that in the Royal Household a system of service stations was developed. Two plans for these, one for the Ball Supper Room in 1911 and one for the Ballroom in 1926, show that the stations were numbered, and each was given a senior member of staff to oversee a team of juniors.

There were up to four staff at each station. This system remains in place today, and each station is still numbered.

The stations are laid in the same way as the table with each having everything necessary for the entire meal. A typical serving station will carry claret jugs of red wine, decanters of port, jugs of water and other soft drinks, serving spoons and forks, salad plates, crumb dishes, dessert dishes and finger bowls on doilies and further plates. There are sugar casters for the later courses, knives and forks for the fruit course, and small linen napkins to protect the hands of the footmen from the hot plates.

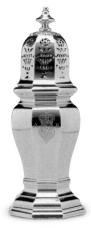

Livery has traditionally been a way of distinguishing members of the sovereign's staff, and until the reign of Charles II it was worn by all retainers in the household. Henry VIII's wardrobe accounts make provision for 'cootys [coats] of grene clothe styched with grene silke, having buttons of like silke' for the grooms who served in his private apartments, whilst his page wore a long gown 'furred with conye [rabbit fur] and lambe'. It became more usual for the livery to reflect the colours in the royal coat of arms and red, dark blue and gold have predominated since the 18th century. These colours are still in use today although with considerably less gold braid than in earlier reigns. Until 1960 pages and footmen were required to powder their hair for state occasions such as banquets.

The current livery was adopted in 1967. At modern banquets, senior staff and pages wear a stiff white shirt, white bow tie, white waistcoat, very dark blue tailcoat with velvet

collar and black trousers. Footmen wear a scarlet tailcoat with black collar and cuffs over a black waistcoat, all trimmed with gold braid. Their brass buttons are stamped with a crown or royal monogram, a custom dating from the 18th century.

During the banquet one of the military orchestras always plays music from the gallery above. The regiments alternate in this duty.

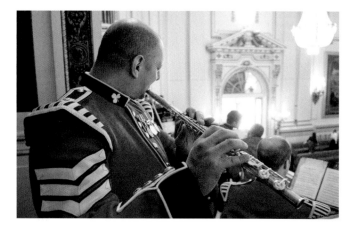

Some weeks before the banquet, the Director of Music submits his suggestions for the programme of music to be played. As with every other aspect of the meal, this is approved by The Queen herself. Like those serving the meal, the Director of Music relies on the Palace Steward to know when to commence playing and when to silence the orchestra. It is particularly important to co-ordinate the music with the arrival of the Royal Procession, and the drum-roll before the speeches.

Music has played an important role from the earliest times. These Elizabethan wooden trenchers (plates; see below) are each inscribed with a verse. Guests were intended to sing or declaim what was written on them – these verses were often homilies on sobriety and virtue, and many were taken from the Bible.

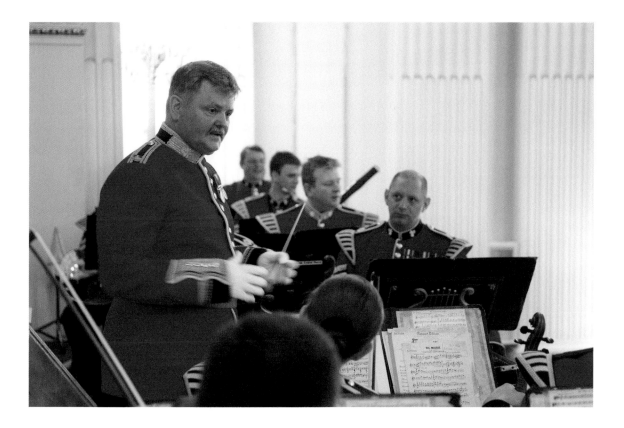

Sir Frederick Ponsonby recorded a disastrous evening when one of the staff had forgotten to notify the band in advance that they would be required to play. An emergency note was sent to the barracks. The band normally played on a specially constructed terrace outside the State Dining Room at Windsor, which could only be accessed in advance of the meal. Ponsonby arranged with the fire brigade to put ladders in place leaning up against the terrace, so that the band could scale up. They failed to arrive in time to play the National Anthem but Ponsonby later wrote that 'as I sat down I saw through the window dark figures climbing on to the small Terrace, and before the Queen had had a mouthful of soup the band struck up the overture'.

Tuesday 28th June 1853

ROYAL BANQUET,
ST. GEORGE'S HALL,
JANUARY 25, 1842.

SELECTION OF MUSIC,
PERFORMED BY
THE COMBINED BANDS
OF
THE ROYAL REGIMENT OF HORSE GUARDS,
AND
72D, DUKE OF ALBANY'S OWN HIGHLANDERS.

MARCH	"Triomphale,"	Ries.
OVERTURE	"Op. 24,"	Mendelssohn.
WALTZ	"Jubel Klänge aus Albion,"	Labitzky.
CHORUS	"Schmückt die Altäre,"	Beethoven.
QUADRILLE	"Polichinelle,"	Musard.
OVERTURE	"Les Diamans de la Couronne,"	Auber.
GALOP	"Rococo,"	Labitzky.

GOD SAVE THE QUEEN

Queen Victoria, who was a keen musician herself, ordered music for each banquet, both during the meal and afterwards for entertainment. The programme of music played at The Prince of Wales's christening banquet in 1842 is shown below left, whilst the list of staff at Prince Leopold's christening banquet in 1853 records 24 singers, 22 choristers, 11 singing boys and 30 bandsmen. Two bands played – the Scots Fusilier Guards during the dinner, and the Private Band in the Throne Room afterwards.

At the first banquet held in the Ballroom at Buckingham Palace, the Royal Regiment of the Artillery band played selections from Brahms, Wagner, Sibelius and Handel.

Programme of Music
TO BE PERFORMED BY
The Band
of the Royal Regiment of Artillery.

1.	March	"Civil und Militair"	Schrammel
2.	Suite of Hungarian Dances		Brahms
3.	Menuet		Paderewski
4.	Selection	"Tannhäuser"	Wagner
5.	Barcarolle from "Les Contes d'Hoffmann"		Offenbach
6.	Largo		Handel
7.	Idyll	"Am Mühlbach"	Eilenberg
8.	Valse Triste		Sibelius
9.	Overture	"Oberon"	Weber
10.	Masque from "As you like it"		Ed. German

Conductor E. C. STRETTON, Bandmaster, R.A.

Buckingham Palace. 9th May, 1914.

The orchestra is also required to play the National Anthem of the visiting nation. These instructions to the Director of Music on how to play the *Marseillaise* were set out for a dinner held for the French President in March 1939.

Music has also featured as an after-dinner entertainment. This was particularly true in the reign of Queen Victoria, who invited opera singers and other musicians to the Palace to perform.

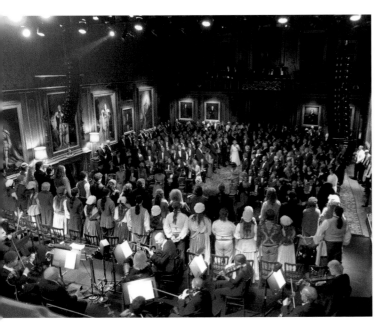

In 1960, when The Queen entertained President de Gaulle of France, a spectacular firework display with music was given in the gardens of the Palace.

As recently as 2004, following a dinner in honour of President Chirac, designed to celebrate a century of the *Entente Cordiale*, scenes from *Les Misérables* were performed in the Waterloo Chamber at Windsor Castle (left).

The end of the banquet is signalled by the arrival of twelve pipers who are drawn from the Scots or Irish Guards and accompanied by The Queen's Piper. This is another tradition that dates from the days of Queen Victoria, who was the first monarch to employ a full-time Piper on her staff. He can be seen in the watercolour (top left) of the 1855 banquet held in the Waterloo Chamber at Windsor Castle.

Music Programme

March	FOLIES BERGERE	*Lincke*
Selection	BROADWAY TONIGHT	*Chase*
Waltz	BAL MASQUE	*Fletcher*
Song	A MAN AND A WOMAN	*Lai*
Selection	LEROY ANDERSON FAVOURITES	*Anderson*
Dance	ENGLISH DANCE NO 1	*Quilter*
Selection	TRIBUTE TO HENRY MANCINI	*Arr. Custer*
Popular	SOUNDS OF THE CARPENTERS	*Arr. Lowden*
Suite	THREE IRISH SCENES	*Naylor*
Selection	HIGH SOCIETY	*Cole Porter*
		Arr. Rapley
Intermezzo	FLEURETTE D'AMOUR	*Fletcher*
Classical Suite	SALUTE TO HANDEL	*Arr. Custer*
Selection	LAND OF THE SHAMROCK	*Charrosin*

Major S. Barnwell
Director of Music, Irish Guards

Pipe Programme

March	THE BALMORAL HIGHLANDERS
Strathspey	ARNISTON CASTLE
Reel	LEXY McASKILL
March	THE BLUE BONNETS O'ER THE WATER

Pipe Major R. Weir
2nd Battalion, The Royal Regiment of Scotland
(The Royal Highland Fusiliers)

After processing around the banqueting table the pipers play briefly at one end of the room. Their exit is the sign for The Queen and her guests to retire for coffee and *petits fours*.

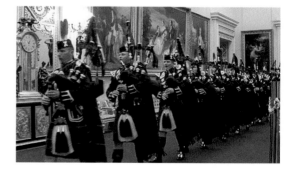

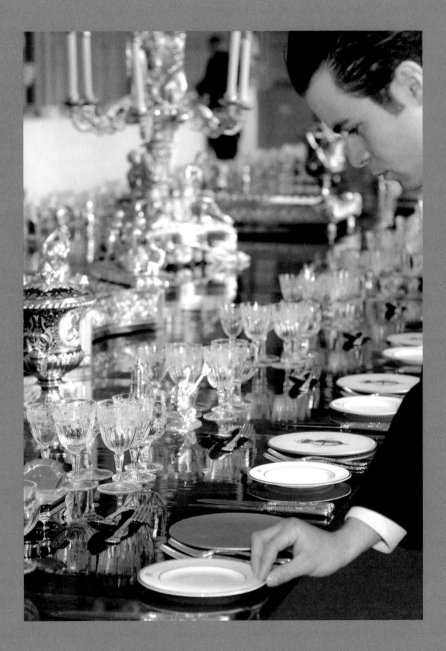

Since 1952 The Queen has entertained 97 Heads of State
at the following State Visits:

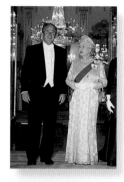

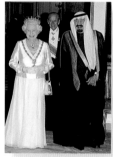

28 June–1 July 1954	King Gustaf and Queen Louise of Sweden
14–16 October 1954	Emperor Haile Selassie of Ethiopia
25–28 October 1955	President and Madame Craveiro Lopes of Portugal
16–19 July 1956	King Faisal of Iraq
13–16 May 1958	President and Signora Gronchi of Italy
21–23 October 1958	President Heuss of Germany
5–8 May 1959	The Shahanshah of Iran
5–8 April 1960	President and Madame de Gaulle of France
19–21 July 1960	King Bhumibol and Queen Sirikit of Thailand
17–20 October 1960	King Mahendra and Queen Ratna of Nepal
10–13 July 1962	President and Mrs Tubman of Liberia
16–19 October 1962	King Olav V of Norway
14–17 May 1963	King Baudouin and Queen Fabiola of Belgium
12–23 June 1963	President Radhakrishnan of India (Commonwealth visit)
9–12 July 1963	King Paul I and Queen Frederika of Greece
26 May–4 June 1964	President Ferik Ibrahim Abbood of Sudan
13–17 July 1965	President and Señora de Frei of Chile
17–21 May 1966	President and Frau Jonas of Austria
19–28 July 1966	King Hussein and The Princess Muna al Hussein of Jordan
17–25 November 1966	President Ayub Khan of Pakistan (Commonwealth visit)
9–17 May 1967	King Faisal of Saudi Arabia
1–8 November 1967	President and Madame Cevdet Sunay of Turkey
22–30 April 1969	President Saragat and Signora Santacatterina of Italy

15–20 July 1969	President and Madame Kekkonen of Finland
5–8 October 1971	Emperor Hirohito and the Empress of Japan
7–10 December 1971	King Zahir Shah of Afghanistan
11–15 April 1972	Queen Juliana and Prince Bernhard of The Netherlands
13–16 June 1972	The Grand Duke and Grand Duchess of Luxemburg
24–27 October 1972	President and Frau Heinemann of Germany
3–6 April 1973	President and Señora de Echeverria of Mexico
12–15 June 1973	General and Mrs Gowon of Nigeria
11–14 December 1973	President and Madame Mobutu of Zaire
30 April–3 May 1974	Queen Margrethe and Prince Henrik of Denmark
9–12 July 1974	The Yang di-Pertuan Agong and the Raja Permaisuri of Malaysia
8–11 July 1975	King Carl Gustaf of Sweden
18–21 November 1975	President Nyerere of Tanzania
4–7 May 1976	President and Senhora Geisel of Brazil
22–25 June 1976	President and Madame Giscard d'Estaing of France
13–16 June 1978	President and Madame Ceauşescu of Romania
14–17 November 1978	President and Senhora Eanes of Portugal
12–15 June 1979	President Arap Moi of Kenya
13–16 November 1979	President and Madame Soeharto of Indonesia
18–21 November 1980	King Birendra and Queen Aishwarya of Nepal
17–20 March 1981	President Shagari of Nigeria
9–12 June 1981	King Khaled of Saudi Arabia
16–19 March 1982	Sultan Qaboos Bin Al Said of Oman
7–9 June 1982	President and Mrs Reagan of the United States of America
16–19 November 1982	Queen Beatrix and Prince Claus of The Netherlands
22–25 March 1983	President and Mrs Kaunda of Zambia

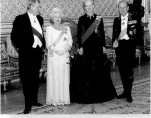

10–13 April 1984	Shaikh Isa bin Sulman Al Khalifa of Bahrain
23–26 October 1984	President and Madame Mitterrand of France
16–19 April 1985	President Banda of Malawi
11–14 June 1985	President and Señora de la Madrid of Mexico
12–15 November 1985	Sheikh Khalifa bin Hamad Al-Thani of Qatar
22–25 April 1986	King Juan Carlos and Queen Sofia of Spain
1–4 July 1986	President and Freifrau von Weizsacker of Germany
24–27 March 1987	King Fahd of Saudi Arabia
14–17 July 1987	King Hassan II of Morocco
12–15 April 1988	King Olav V of Norway
12–15 July 1988	President Evren of Turkey
8–11 November 1988	President and Madame Diouf of Senegal
9–12 May 1989	President and Mrs Babangida of Nigeria
18–21 July 1989	Sheikh Zayed bin Sultan Al Nahyan of the United Arab Emirates
3–6 April 1990	President and Shrimali Venkataraman of India
23–26 October 1990	President Cossiga of Italy
23–26 April 1991	President and Mrs Walesa of Poland
23–26 July 1991	President and Mrs Mubarak of Egypt
3–6 November 1992	The Sultan of Brunei and the Raja Isteri
27–30 April 1993	President and Senhora Soares of Portugal
9–12 November 1993	The Yang di-Pertuan Agong and the Raja Permaisuri Agong of Malaysia
17–20 May 1994	President Mugabe of Zimbabwe
5–8 July 1994	King Harald and Queen Sonja of Norway
23–26 May 1995	Shaikh Jabir al Ahmed Jabir al Sabah (the Amir) of Kuwait
17–20 October 1995	President and Madame Ahtisaari of Finland

14–17 May 1996	President and Madame Chirac of France
9–12 July 1996	President Mandela of South Africa
25–28 February 1997	President and Mrs Weizman of Israel
2–5 December 1997	President and Senhora Cardoso of Brazil
26–29 May 1998	Emperor Akihito and Empress Michiko of Japan
1–4 December 1998	President and Frau Herzog of Germany
22–25 June 1999	President and Mrs Goncz of Hungary
19–22 October 1999	President and Madame Wang Yeping of China
16–18 February 2000	Queen Margrethe II and Prince Henrik of Denmark
12–15 June 2001	President and Mrs Mbeki of South Africa
6–9 November 2001	King Abdullah II and Queen Rania of Jordan
24–27 June 2003	President Putin and Mrs Putina of the Russian Federation
18–21 November 2003	President and Mrs Bush of the United States of America
5–7 May 2004	President Kwasniewski and Mrs Kwasniewska of Poland
18–19 November 2004	President and Madame Chirac of France
	(Official Visit to mark the centenary of the *Entente Cordiale*)
1–3 December 2004	President and Mrs Roh Moo-Hyun of South Korea
15–17 March 2005	The President of the Italian Republic and Signora Ciampi
25–27 October 2005	King Harald and Queen Sonja of Norway (Official Visit)
8–10 November 2005	The President of the People's Republic of China and
	Madame Liu Yongqing
7–9 March 2006	The President of Brazil and Senhora Marisa Letícia Lula da Silva
13–15 March 2007	The President of the Republic of Ghana and Mrs Kufuor
28 October–1 November 2007	
	King Abdullah Bin Abdul Aziz Al Saud of Saudi Arabia
26–28 March 2008	President and Madame Sarkozy of France

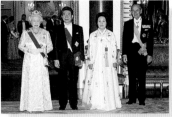

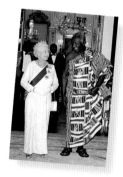

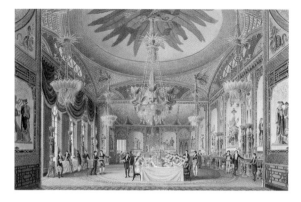

Illustrations

Unless otherwise stated, items in the Royal Collection or Royal Archives are respectively: The Royal Collection © 2008 HM Queen Elizabeth II, and: The Royal Archives © 2008 HM Queen Elizabeth II.

Unless otherwise indicated photography was supplied by The Royal Collection's Picture Library. Royal Collection Enterprises are grateful for permission to reproduce those items listed below for which copyright is not held by The Royal Collection.

Page 1
• Louis Haghe, *Banquet on the occasion of the christening of Prince Leopold, Picture Gallery, Buckingham Palace, 28 June 1853* (detail; watercolour; RCIN 919917)

Page 2
• A selection of copper jelly moulds (including RCIN 31908, 34475, 34476, 34477, 34478)

Page 3
• Menu for the Wedding Breakfast, Buckingham Palace, 26 April 1923 (detail; RA F&V/ Weddings/1923/GVI: wedding breakfast menu)
• Douglas Morison, *The State Dining Room, Buckingham Palace*, 1843 (detail; watercolour; RCIN 919898)

Page 4
• Banquet in honour of President Sarkozy of France, Windsor Castle, March 2008, photograph by Ian Jones: © Ian Jones

Page 5
• Francis Sandford, *James II's coronation banquet: the King's table*, 1685 (etching; detail; RCIN 750184)
• The Queen with President Sarkozy of France, March 2008: © PA Photos

Page 6
• The Queen inspecting the table in St George's Hall, Windsor Castle, photograph by Ian Jones: © Ian Jones

Page 7
• *James I entertaining the Spanish Ambassadors*, 18 November 1624: © The Trustees of the British Museum
• Gerrit Houckgeest, *Charles I and Henrietta Maria dining in public*, 1635 (oil on panel; RCIN 402966)
• British School, *Field of the Cloth of Gold*, *c*.1545 (detail; oil on panel; RCIN 405794)

Page 8
• Wenceslaus Hollar, *Garter banquet in St George's Hall*, 1671 (etching; RCIN 802368)
• Luke Clennell, *Banquet given by the Corporation of London to the Prince Regent, the Emperor of Russia and the King of Prussia, 18 June 1814*: © Guildhall Art Gallery, Corporation of London/The Bridgeman Art Library
• A footman laying the table for a Garter luncheon in the Waterloo Chamber, Windsor Castle, June 2004. Photograph by Simon Roberton

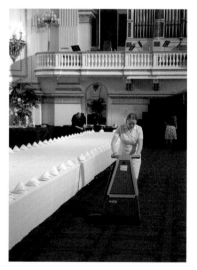

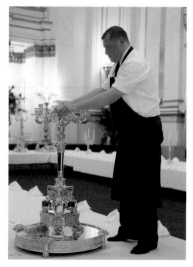

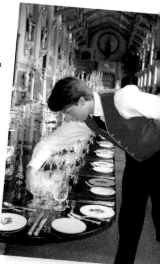

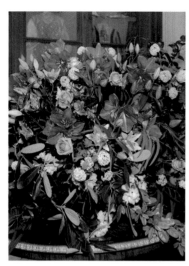

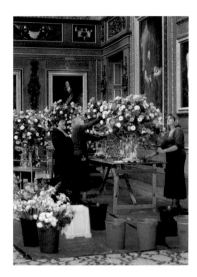

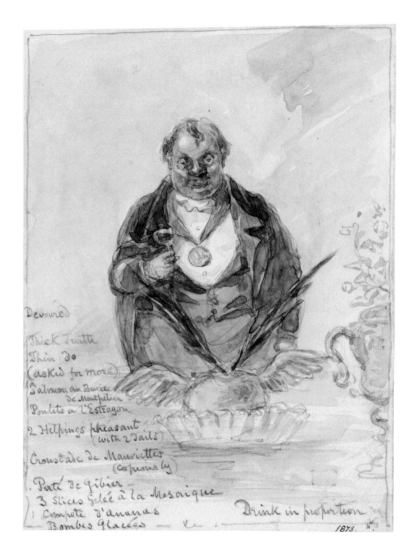

Devoured

Thick Turtle
Thin Do
(asked for more)
Salmon au Beurre
de Montpelier
Poulets à l'Estragon

2 Helpings pheasant
(with 2 Tails)

Croustade de Mauviettes
(copiously)

Paté de Gibier —
3 slices Gelée à la Mosaique
Compote d'ananas
Bombes Glacées — &c.

Drink in proportion

1873.